A PRESIDENT IN YELLOWSTONE

THE CHARLES M. RUSSELL CENTER SERIES ON
ART AND PHOTOGRAPHY OF THE AMERICAN WEST
B. BYRON PRICE, GENERAL EDITOR

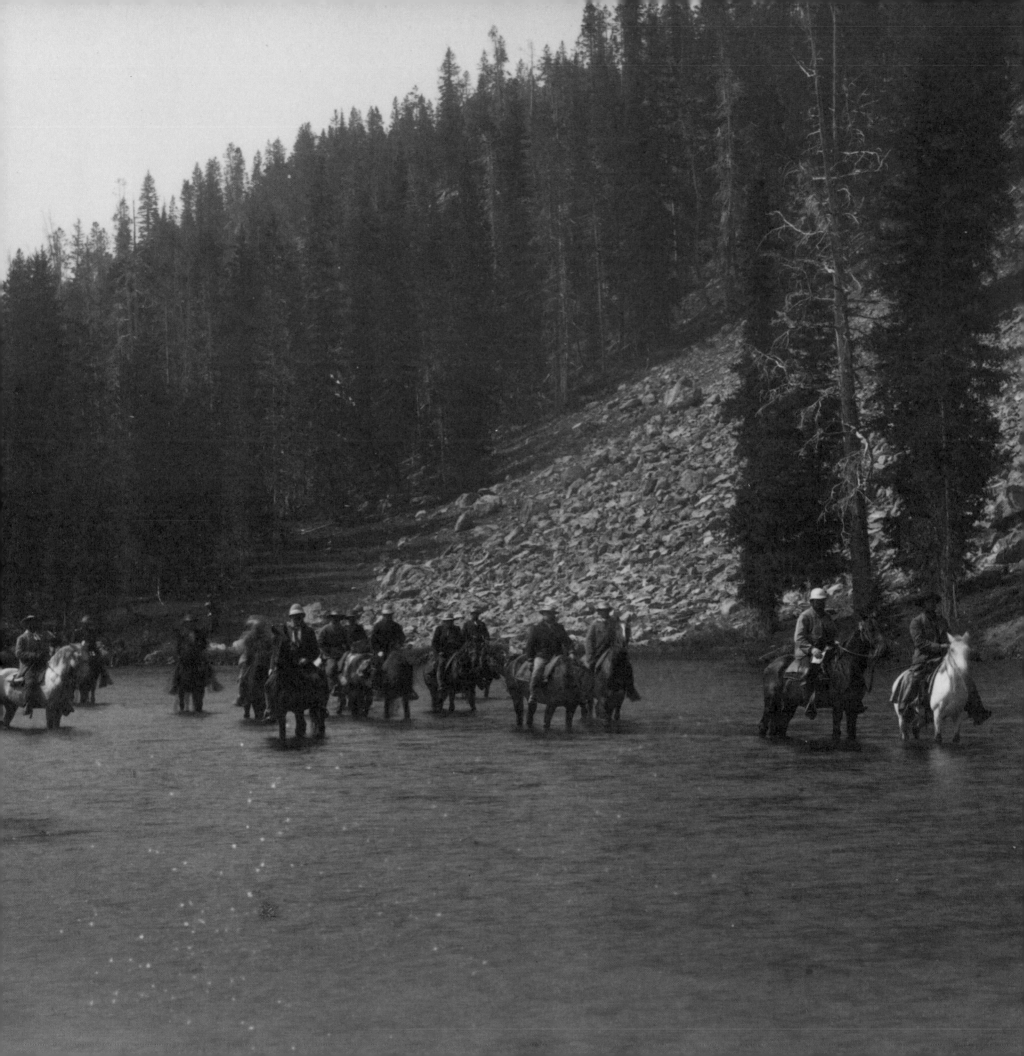

A PRESIDENT IN YELLOWSTONE

———◆———

THE F. JAY HAYNES PHOTOGRAPHIC ALBUM
OF CHESTER ARTHUR'S 1883 EXPEDITION

FRANK H. GOODYEAR III

UNIVERSITY OF OKLAHOMA PRESS : NORMAN

ALSO BY FRANK H. GOODYEAR III

Red Cloud: Photographs of a Lakota Chief (Lincoln, 2003)
Zaida Ben-Yusuf: New York Portrait Photographer (London, 2008)
Faces of the Frontier: Photographic Portraits from the American West, 1845–1924 (Norman, 2009)

THIS BOOK IS PUBLISHED WITH THE GENEROUS ASSISTANCE
OF THE YELLOWSTONE PARK FOUNDATION.

LIBRARY OF CONGRESS CATALOGING-IN-PUBLICATION DATA

Goodyear, Frank Henry, 1967–

A president in Yellowstone : the Frank Jay Haynes photographic album of
Chester Arthur's 1883 expedition / Frank H. Goodyear III.

 pages cm. — (The Charles M. Russell Center series on art and
 photography of the American west ; v. 11)

Includes bibliographical references and index.

ISBN 978-0-8061-4355-2 (hardcover : alk. paper)

1. Arthur, Chester Alan, 1829-1886—Travel—Yellowstone National
Park—Pictorial works. 2. Presidents—Travel—Yellowstone National Park—
History—19th century—Pictorial works. 3. Yellowstone National Park—
History—19th century—Pictorial works. 4. Presidents—United States—
Biography—Pictorial works. 5. Haynes, F. Jay (Frank Jay), 1853–1921.
I. Haynes, F. Jay (Frank Jay), 1853–1921. II. Title.

 E692.G66 2012
 978.7'52—dc23

 2012036675

*A President in Yellowstone: The Frank Jay Haynes Photographic Album of Chester
Arthur's 1883 Expedition* is Volume 11 in The Charles M. Russell Center Series
on Art and Photography of the American West.

The paper in this book meets the guidelines for permanence and durability of
the Committee on Production Guidelines for Book Longevity of the Council
on Library Resources, Inc. ∞

This book is dedicated to my grandfather, Frank H. Goodyear, Sr., and to my parents, Frank and Betsy Goodyear, Jr.

———•◆•———

CONTENTS

ACKNOWLEDGMENTS

Many people have been generous with their assistance during the development of this book. In particular, I appreciate the support of Lee Whittlesey at the Yellowstone National Park Research and Heritage Center, Kim Allen Scott at Montana State University, Lory Morrow and Becca Kohl at the Montana Historical Society, George Miles at Yale University, Anne Peterson at Southern Methodist University, Carol Johnson at the Library of Congress, and Pamela Henson at the Smithsonian Institution Archives. At the National Portrait Gallery, I want to thank my colleagues Ann Shumard and Amy Baskette. I have enjoyed working with the University of Oklahoma Press, and wish to express my gratitude in particular to Kathleen Kelly and Alice Stanton. Many thanks also to Gerry Krieg for drafting the book's map. For helping make this project possible, I also wish to acknowledge Mary Jo Veverka, Diana and Mallory Walker, and the Jane Smith Turner Foundation for their support through the Yellowstone Park Foundation. I am grateful to foundation president Karen Bates Kress and Nina Jaeger for championing the book.

I traveled to Wyoming for the first time when I was one year old. It is always a joy to return. To my grandfather, my parents, my two sisters and their families, and my wife Anne, many thanks for making Wyoming so special.

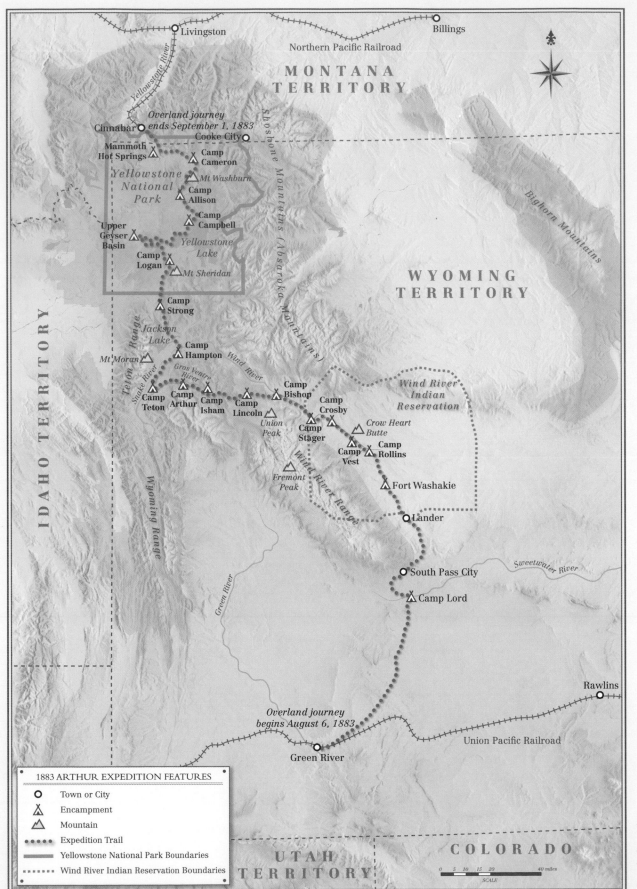

Livingston

Billings

Northern Pacific Railroad

MONTANA
TERRITORY

*Overland journey
ends September 1, 1883*

Cinnabar

Cooke City

Yellowstone River

Mammoth
Hot Springs

Camp
Cameron

Shoshone Mountains (Absaroka Mountains)

Bighorn Mountains

*Yellowstone
National
Park*

Mt Washburn

Camp
Allison

Camp
Campbell

Upper
Geyser
Basin

*Yellowstone
Lake*

WYOMING
TERRITORY

Camp
Logan

Mt Sheridan

Camp
Strong

*Jackson
Lake*

Camp
Hampton

*Wind River Indian
Reservation*

Mt Moran

Teton Range

Snake River

*Gros Ventre
River*

Wind River

Camp
Bishop

Camp
Crosby

Camp
Teton

Camp
Arthur

Camp
Isham

Camp
Lincoln

*Crow Heart
Butte*

Camp
Stager

Camp
Vest

Camp
Rollins

*Union
Peak*

IDAHO TERRITORY

Wyoming Range

*Fremont
Peak*

Wind River Range

Fort Washakie

Lander

Green River

Sweetwater River

South Pass City

Camp Lord

Rawlins

*Overland journey
begins August 6, 1883*

Union Pacific Railroad

Green River

UTAH
TERRITORY

COLORADO

1883 ARTHUR EXPEDITION FEATURES

○ Town or City

⛺ Encampment

▲ Mountain

••••• Expedition Trail

── Yellowstone National Park Boundaries

•••• Wind River Indian Reservation Boundaries

0 5 10 15 20 40 miles
SCALE

President Chester A.
Arthur's 1883 Expedition to
Yellowstone National Park.

Cartography by Gerry Krieg.

A PRESIDENT IN
YELLOWSTONE

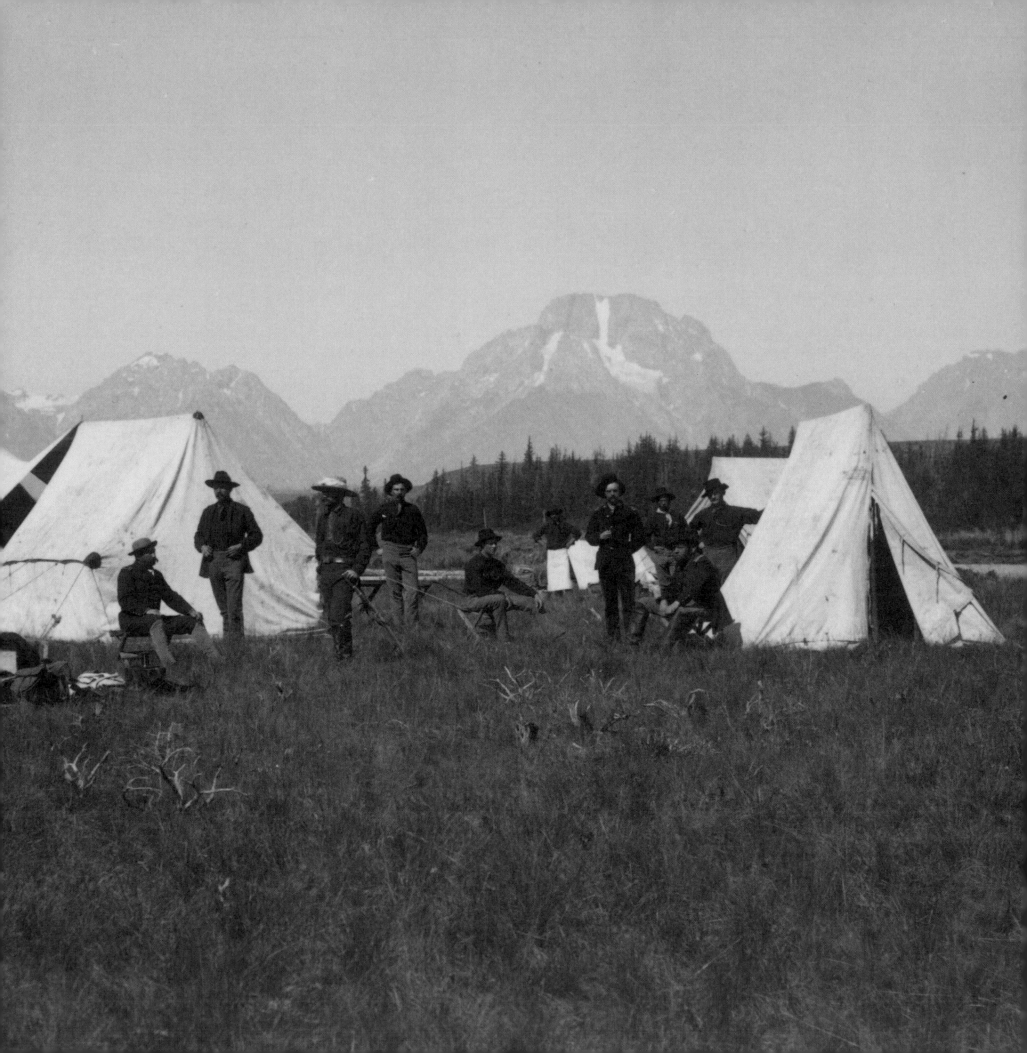

INTRODUCTION

———◆———

When Chester A. Arthur left the White House on the morning of July 30, 1883, he began a trip that would be longer than any he had ever taken. The fifty-three-year-old president was fond of traveling, though he had never been as far as where he was heading. In fact, no sitting U.S. president had ever embarked on such a long and potentially hazardous trip. His destination was Yellowstone National Park, which had been established by an act of Congress only eleven years earlier, and his host and primary guide was Philip H. Sheridan, the famed Union general who had served since 1878 as the commander of the U.S. military in the West.[1]

Any journey involves a degree of uncertainty, but Arthur left knowing that he was courting a number of potential risks. Since General Sheridan first approached the president about such a trip the previous winter, Arthur had recognized that certain factors would need to be considered before he accepted. It wasn't so much the wilderness he was going to pass through or the Native Americans he was scheduled to meet that primarily concerned him. During conversations throughout the first part of the year Sheridan had assured him that his safety and comfort would not be compromised. He would travel with a seventy-five-man military escort, capable guides, and all of the supplies that he could possibly need. Sheridan had completed ostensibly the same trip during the two previous summers, and no surprises were anticipated. In addition, the Native Americans the president was scheduled to meet had long been friendly towards the United States and were prepared to welcome him warmly.

Sheridan did explain, though, that a significant portion of the trip would be made on horseback. In fact, once they arrived at Fort Washakie in southwestern Wyoming Territory, the party would travel overland on horseback for roughly three weeks and cover a distance of more than 330 miles. They would sleep in tents, as few permanent structures were available along the route. Although August was understood to be the best month in terms of weather, there was no guarantee that they might not encounter freezing temperatures and possibly an early snow storm. Such physical hardships probably did not overly concern Arthur. An avid outdoorsman, he enjoyed being on a horse and often went riding, even during his presidency.

What Arthur enjoyed most especially, though, was fishing. He had fished all his life and had traveled in the past as far as Canada to the north and Florida to the south to pursue such opportunities. He was known as an accomplished angler. As George Bird Grinnell, the editor of *Forest and Stream*, wrote the spring before Arthur's Yellowstone trip, "no matter what the judgment of the future may be upon the administration of President Arthur, his fame as an angler is established for all time on the strength of that fifty-pound salmon." Three years earlier Arthur had caught the largest

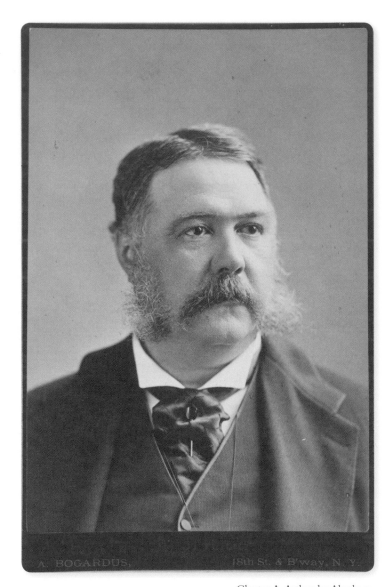

Chester A. Arthur by Abraham
Bogardus, albumen silver print,
c. 1881. National Portrait Gallery,
Smithsonian Institution

salmon ever recorded with a fly on a river in Canada. In the same profile of "our angling president," Francis Endicott, the president of the National Rod and Reel Association, commented that Arthur "casts a salmon fly beautifully, he casts a trout fly superbly, and he casts a bass bait equal to anyone . . . it is an exceedingly rare thing to find a person who is capable of doing all three very well . . . I unhesitatingly pronounce him not only the first magistrate, but the first angler in the land."[2] In discussing the outline of the journey, Sheridan had foregrounded the exceptional fishing streams that awaited Arthur. While there were a number of reasons for making this excursion, the opportunity to fish almost every day certainly excited the president.

Sheridan also explained that the trip would not adversely affect Arthur's responsibilities as chief executive. Telegraph lines were in place that would permit the president to communicate with officials in Washington in order to keep abreast of any notable developments. Although such lines would not be available after they left Fort Washakie, Sheridan indicated that two military courier lines would be established for that period of the trip when they were beyond them. A series of soldiers on horseback would carry daily dispatches to the closest telegraph station. No matter how far removed they were, the party would still be able to send off and receive messages every day. Newspapers would also be able to be delivered to the party. As the United States was then at peace, and Arthur was not embroiled in any particularly feverish controversy, the time and circumstances seemed right for such an excursion, if he was indeed interested. Such were the plans that Sheridan laid out for the president in the spring of 1883.

Yet, there were real risks that must certainly have concerned Arthur, his family, and his political advisors. Most especially troubling was the state of his health. In the fall of 1882, newspapers first reported that Arthur was being diagnosed by the surgeon general as having Bright's Disease, a potentially fatal kidney affliction. Arthur's ailment had first been discovered not long after he became president in September 1881, but he had been able to keep it private. Although officials refuted the newspaper reports,

Arthur's fragile health was made apparent in the spring of 1883. While on a fishing trip in the South, he became severely sick, was forced to cancel various social plans, and ultimately was rushed back to Washington for care. Reports about the president being bedridden in Savannah, Georgia, circulated widely, and some speculated that his death was imminent.[3] This attention in the press angered Arthur, though privately he spoke about his precarious condition. In a letter written before his southern vacation to his son Alan, who was then a student at Princeton, Arthur explained, "I have been so ill since the adjournment [of Congress earlier in the week] that I have hardly been able to dispose of the accumulation of business still before me."[4]

Arthur was well aware of life's fragility. He had lost his wife to pneumonia three years earlier—a tragedy from which he never fully recovered. Further, Arthur was then president because of the death of James Garfield, who had been killed by an assassin's bullet. Although his illness and the sudden and unexpected deaths of his wife and President Garfield weighed on him, they did not lead him to live a more cautious life, at least in any noticeable manner. A month after his seizure in Savannah, he was back in the public spotlight to mark the dedication of the Brooklyn Bridge. Eager to perform his presidential responsibilities, Arthur traveled to New York by train and made remarks at the ceremony. Yet, many remarked about his poor health and aged appearance, and again rumors sprang up about the state of his well-being. After the dedication he retired to his Manhattan hotel, where he remained for a week trying to regain his strength. Once back in Washington, he retreated to the Soldiers' Home for further rest. In light of these health concerns, the idea of Arthur leaving Washington for a six-week, 4,500-mile trip—a significant proportion of which would be carried out on horseback in the wilds of Wyoming—must have struck many close to the president as ludicrous, perhaps even suicidal.

The other factor that weighed on Arthur and his advisors as he decided whether to accept Sheridan's invitation was the impact that such a trip might have on the nation—not to mention on his own political future. As president, his primary duties were in Washington. Because Arthur became president following Garfield's assassination, there was no sitting vice president at the time, and his being away for so long might actually jeopardize the stability of the union. Should he die or become incapacitated, the president pro tempore from the Senate would for the first time in American history assume the presidency, a situation that Republicans and Democrats alike wished to avoid. As such, Arthur's leaving Washington to go fishing in Wyoming was seen by many as a selfish, potentially foolhardy decision, especially for someone who might seek the Republican nomination for the presidency during the elections of 1884. Although Arthur often eschewed the idea that he was interested in running for president, the newspapers during the summer of 1883 were already beginning to handicap the race for the nomination and ultimately the White House. Many Americans harbored serious skepticism about Arthur's political abilities at the time he became president, and in 1883 he was by no means the Republican favorite. Yet, his increasing independence from the political machine of which he had long been a part and a series of legislative achievements, most especially the passage of the Pendleton Act, a landmark civil service reform bill signed in January 1883, led many to reconsider Arthur's previous reputation. While several factors kept him from aggressively pursuing the nomination, his claims about not wanting another term appear to be insincere. As a former clerk who worked in the Arthur White House later recalled, "Mr. Arthur wanted and I think expected to be nominated for a second term. He thought he deserved it and that he would receive it."[5]

Although Arthur was informed about the outline of the proposed trip in April, he had still not confirmed his participation two months later. On June 14, General Sheridan wrote Frederick J. Phillips, Arthur's private secretary, and reviewed the route they would take and the equipment that the president would need. While Arthur was required to bring his own clothes, foul weather gear, and fishing equipment, Sheridan would supply everything else, including horses, guns, tents, and food. He also explained that Arthur would be permitted to bring one guest and that a doctor

would accompany the party. And he impressed upon Phillips that he needed an answer from the president shortly, for there were many preparations to make. In closing, he explained that if Arthur decided not to participate, he wasn't going to go either.[6]

Sometime during the last week of June or the first week of July Arthur decided to go. In conveying his answer to Sheridan, it's unclear what, if any, stipulations he made at the time. Arthur clearly had one requirement, though: that no reporters would accompany the expedition. The president had long loathed the press. As an associate commented later that fall, Arthur had a "mental fear" of reporters. "I never came in contact with a man in my life who would run into a hole so quick as Chet Arthur when he saw a newspaper article," he explained.[7] Indeed, the president was sensitive to criticism from the press and rarely gave interviews. Likewise, he cherished his privacy and wished to keep any ailments and other personal matters out of public view. Although reporters sought permission to accompany them to Yellowstone, after news concerning the trip became known, the organizers flatly refused. As Sheridan expressed to Secretary of War Robert Todd Lincoln, one of the excursion's participants, three days before Arthur's departure from Washington, "If we have a newspaper man along our pleasures will be destroyed."[8] That said, in order to make a record of the trip and communicate with the public, they agreed that Sheridan's younger brother Michael V. Sheridan—who served then as the "Military Secretary" to his brother with the rank of assistant adjutant general—would accompany the expedition and write summaries of their daily activities and travels. These reports would be reviewed by the president, couriered to the nearest telegraph station, and then circulated to the press through the offices of the Associated Press.

While this arrangement seemed to some like an admirable solution, the ban on reporters did not entirely succeed in keeping the press from doing their own independent reporting on the trip or editorializing about it. Despite not being present, they did not hesitate to analyze the expedition, joke about it, and even fabricate stories during it—much to the consternation of Arthur and the rest

of the party. Of foremost interest in the papers for weeks before their departure was the question of whether the entire enterprise was a wasteful and possibly corrupt government boondoggle. Why, many asked, should the American taxpayers have to underwrite this costly fishing trip? Further, how could the president substantiate taking so much time away from his official duties—not to mention possibly putting himself in harm's way? Several Democratic journals speculated that the whole trip was cooked up by the railroads and other private entrepreneurs to advance their own commercial interests. As a writer for the *Rocky Mountain News* in Denver editorialized, "President Arthur has consented to make an advertisement of himself for the enterprising syndicate which has built a mammoth hotel in Yellowstone National Park, and about August 1, accompanied by a large party of distinguished dead heads, he will start from Washington to that new resort of fashion."[9] Other papers came to Arthur's defense, arguing that the president was entitled to a vacation and pointing out that he was paying all of his own expenses. For much of the next month, newspapers and magazines continued to debate these and other questions. Never before had a summer trip by a president elicited such comment.

Ultimately, Arthur and Sheridan were forced to step forward to explain their intentions. On July 16, the *Chicago Tribune* ran an article about the trip that included the following statement from the president:

I have had enough of what is called society in the winter in Washington. I want to get a hundred miles away from the nearest politician, where I can take a rest in my own way, and be relieved from the social and political pressure that is so hard to avoid. I have never seen the section of the country we are going to, nor do I know anything of the people who are the pioneers of civilization and keep on its outermost wave. I will have an opportunity too to practically study the Indian question, which I have wished to do ever since I have been in office. Gen. Sheridan has selected the best guides and scouts he can find to go with us on the trip, and we will see parts of

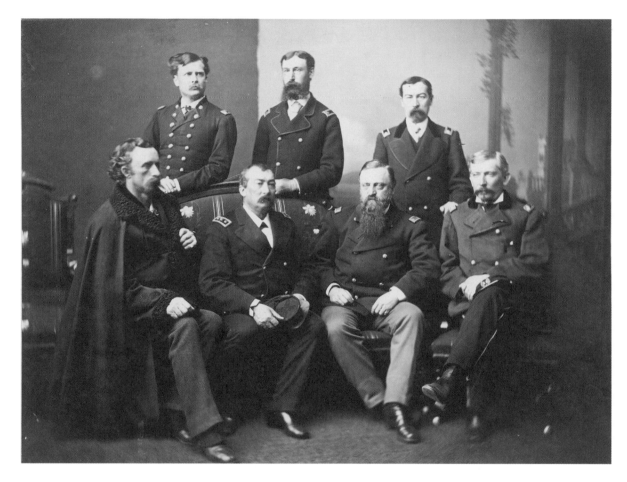

Philip H. Sheridan (seated, second from left) and His Staff Officers, including George A. Custer (seated at left) and Michael V. Sheridan (standing at right) by J. Lee Knight, albumen silver print, 1872. National Portrait Gallery, Smithsonian Institution

a country which has hitherto been almost unknown to white men. As to the spice of danger there may be, that only adds to the interest of the journey. I shall rough it, just as the rest do, live and sleep in the open air, wear out my old hunting suit, and for the first time in my life, become a savage. Such a trip will be worth more to me in instruction and health than twenty seasons at Saratoga or Newport would be.[10]

This quote was excerpted by other newspapers in the days that followed, yet some still remained skeptical.

When Arthur's explanation failed to stem the criticism, General Sheridan stepped forward the following week to answer the charges point by point in a newspaper interview. After explaining that the military under his command had long been planning this expedition and would embark on it regardless of the president's presence, he went on to state that it "would be beneficial to the President and Secretary [Lincoln] in the way of healthful exercise, and in addition give them an opportunity to see something of the West, the frontier people, and some of the military posts." Sheridan continued regarding the importance of visiting Yellowstone, whose boundaries he wished to have extended. "The extension I propose is principally

on the southern line—a country over which we will pass—and I am in hope that the information these gentlemen may acquire will have a tendency to induce Congress to adopt my views." Finally, he acknowledged that "we expect to get some good fishing on the way, and, knowing the President's fondness for this sport, I invited him last winter to go on the expedition. He said he would gladly accept if circumstances would permit. Nothing appears to be in the way, and I feel satisfied he will return with a longer lease of life and more refreshed by his twenty days in the Rocky Mountains than would occur from a rest at any watering place."[11]

While most came to support the trip, the public criticism clearly stung the president. When a New York newspaper reporter questioned him about his "vacation" a week before his departure, he answered abruptly, "Vacation, eh? That is the way all the newspapers talk. They speak of my journeys as junketings. I need a holiday as much as the poorest of my fellow citizens; but it is generally supposed that we people at Washington do not want any rest."[12] Although Arthur longed to get away from the tense political environment in the East, the press would continue to dog him throughout the trip and after.

Given the reality of his presidency, it is perhaps telling that the one guest he invited to accompany him was not a family member, but instead his longtime colleague and advisor Daniel G. Rollins, then the surrogate of New York. His friendship with Rollins extended back to the seven years in the 1870s when Arthur served as the head of the New York Custom House. During his presidential years, Arthur came to depend on Rollins for political counsel, often visiting him during trips to New York City. Charles M. Hendley, a clerk in the Arthur White House, later wrote about their relationship: "[Arthur] was not over industrious. He had always been able to command and to have the details carried out by others . . . He had great confidence in [Rollins's] judgment and in his manner of stating things. Judge Rollins was especially clever in the clarification and presentation of public questions and had much to do with the expression of the President's view in his state papers."[13] Although Arthur's

excursion to Yellowstone would seem to enable him to leave Washington politics far behind, he nevertheless felt inclined to invite his closest advisor.

While the press was unwelcome, they made the decision to commission a photographer to accompany the party to Yellowstone and through the park. General Sheridan was responsible for selecting a suitable photographer.[14] The idea of documenting the trip in this manner may also have been his, though it's unclear whether he knew before the trip how these images might be used. Arthur seems never to have commented on the addition of a photographer. Whereas a journalist was out of the question, including someone to provide a visual record of the trip did not seem to concern Arthur. Perhaps he believed that the resulting images would be kept private, or perhaps he thought that a photographer was far less susceptible to embarrassing the president. Such images might even potentially raise his profile in the eyes of his constituents. Whatever the case, a photographer was to be identified and invited to join the excursion.

Although Sheridan had many potential candidates from which to choose, he reached out to Frank Jay Haynes, a twenty-nine-year-old practitioner based in Fargo, Dakota Territory. Haynes had opened his first commercial studio in Moorhead, Dakota Territory, in 1876 and, after several successful years, had moved to the larger town of Fargo in 1879. While his photographic business focused initially on the portrait trade, he had gravitated increasingly to assignments beyond the studio. In particular, the Northern Pacific Railroad had commissioned him to photograph the construction of their transcontinental line and the lands and communities that abutted the tracks. These images were used to publicize the company and to spur travel, settlement, and investment in the larger region. In 1881, with the railroad's completion still two years off, Charles S. Fee— the company's general passenger agent in St. Paul—invited Haynes to make his first picture-taking venture to Yellowstone. Inspired by what he discovered and encouraged by the positive reception for his photographs, Haynes returned the following year to secure more images, and on that occasion encountered Sheridan, who was

also in the park that summer. While Haynes was neither the first to photograph in Yellowstone, nor the only photographer there during this period, he left enough of an impression on Sheridan that he subsequently invited Haynes to accompany and photograph the president's party.[15]

In selecting Haynes, Sheridan may also have relied on the recommendation of officials with the Northern Pacific Railroad. If so, he would have learned of Haynes's desire to establish a studio within the park itself. Following his first trip in 1881, Haynes came to appreciate the park's potential as a photographic subject and contemplated a summer outpost where he could market images of the park to visitors. At the time a commercial enterprise such as the one that Haynes envisioned required permission from and ultimately a formal lease with the U.S. Department of the Interior. His franchise application was turned down in the summer of 1882 and again in February 1883. As Secretary of the Interior Henry M. Teller explained in a letter to Haynes on this latest occasion, "certain legislation is now pending in Congress relating to the park, in view of which it is not deemed proper at this time to take any action upon applications for such leases."[16] Indeed, much uncertainty surrounded the issue of private businesses within the park. Haynes refused to give up, though, and turned for assistance to officials at the newly established Yellowstone National Park Improvement Company, a private syndicate that had just finished negotiating an exclusive ten-year lease with the Interior Department to provide tourists with accommodations, food, and transportation within the park. After introducing himself and his work, Haynes was appointed on May 5, 1883, as the "official photographer" and "superintendent of art" for the Improvement Company.[17] Within a month, he was selling a range of images from "a large wall tent that stood near the terraces" at Mammoth Hot Springs.[18]

Given Haynes's ambition to establish himself as the premier photographer of the park, he was likely quick to accept Sheridan's invitation. By mid-July he was en route to the Union Pacific rail town of Rawlins, Wyoming, where he expected to meet up with Sheridan and the president's party. He carried with him

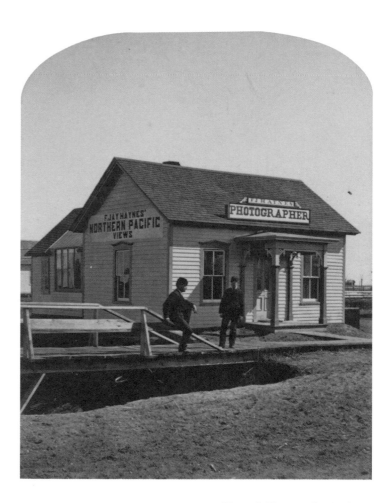

Haynes's Photographic Studio at Moorhead, Dakota Territory, by Frank Jay Haynes, albumen silver print (one half of a stereograph), 1879. Burlingame Special Collections, Montana State University–Bozeman Libraries

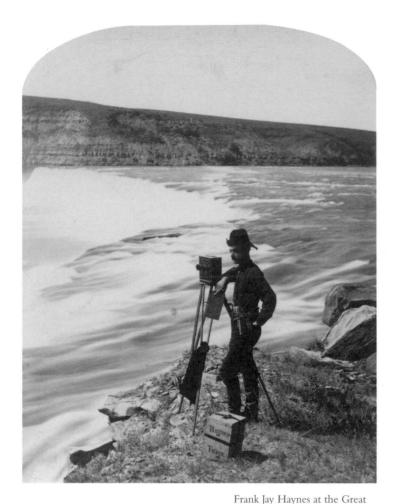

Frank Jay Haynes at the Great
Falls of the Missouri River by
Frank Jay Haynes, albumen
silver print (one half of a
stereograph), 1880. Burlingame
Special Collections, Montana State
University–Bozeman Libraries

two cameras: a large-format camera that created eight-by-ten-inch "Imperial" negatives and a smaller stereograph camera. Perhaps because of space limitations, he brought only thirty-five large-format plates and approximately fifty stereographic plates, a number that he soon acknowledged was far too few. As Haynes arrived in southern Wyoming several weeks prior to the president, he had plenty of time to take a few photographs before Arthur appeared, thereby using several plates that he would later wish he had saved.

When he learned that the president was not going to embark from Rawlins as Sheridan had originally planned, he relocated to Fort Washakie and waited. On the eve of Arthur's arrival, Haynes excitedly wrote to his wife Lily:

> I have two assistants. 1 my "orderly" makes my bed, brings water, and keeps the tent in order, the other "Packer" attends to my Riding Horse and Pack Mules. It takes two mules to carry my outfit and bedding. . . . We will travel lively when we get started as the Party have their dates all fixed and must make them. Pres. Arthur is the first President who ever went so far from Washington . . . I am going to get some nice views and I know the trip will be the best one I ever made. It certainly does not cost anything compared with my other Park trips. . . . I am fully rested and ready to view His Royal Highness as soon as he puts in his appearance. I cannot give you any instructions about business as I have lost all run of it, but do the best you can only don't worry yourself sick.[19]

At the letter's end, he drew a self-portrait cartoon for his four-year-old daughter, Bessie, that he entitled "After the President."

Many at Fort Washakie shared Haynes's anticipation. For more than a month, military officials, guides, and packers had been busily making preparations for the president's arrival. As General Sheridan's lead assistant, Michael Sheridan coordinated the effort and readied the people, horses, and supplies that would be needed. Haynes's inclusion as a member of the party suggested how special this trip was. While the creation of a commemorative album had perhaps not

yet entered the minds of Haynes or the organizers, they understood the importance of making a documentary record of the trip. For Arthur and many others that summer, visiting Yellowstone was a once-in-a-lifetime experience. Haynes's photographs would serve as important keepsakes—reminders of an ambitious journey through territory that few non-Natives had ever traversed. Although they scorned the prying eyes of the press, they embraced the eyewitness images that Haynes's cameras would produce. Despite concerns over his health and political future, Arthur had decided to go forward with the trip, and everyone was now ready to greet him and the other guests.

After the President by Frank Jay Haynes, pencil drawing in a letter to his wife Lily Snyder Haynes, 1883. Burlingame Special Collections, Montana State University-Bozeman Libraries

President Arthur was not alone in traveling to Yellowstone during the summer of 1883. While the announcement of his visit certainly prompted others to embark on a trip to the so-called "Wonderland," much attention was focused on the park that season. Since it was established in 1872, Yellowstone had attracted a modicum of interest from scientists, artists, and curiosity seekers. Estimates suggest that 8,300 visitors had been to the park during the previous eleven summers, and approximately a thousand people annually were visiting in the years immediately leading up to 1883. Yet, in the year of the president's tour, the annual number jumped five-fold.[20] The publicity surrounding Arthur's visit partially explains this dramatic increase, but other factors were equally or even more important. The completion of the Northern Pacific Railroad in September, including a special branch spur that brought visitors just outside the park's north entrance, and the construction of the National Hotel at Mammoth Hot Springs made

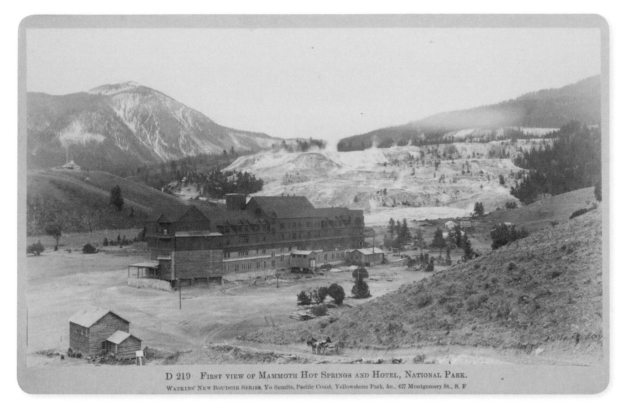

D 219. FIRST VIEW OF MAMMOTH HOT SPRINGS AND HOTEL, NATIONAL PARK.
WATKINS' NEW BOUDOIR SERIES, Yo Semite, Pacific Coast, Yellowstone Park, &c., 427 Montgomery St., S. F

First View of Mammoth Hot Springs and Hotel, National Park by Carleton Watkins, albumen silver print, 1884. Carroll T. Hobart Papers, Yale Collection of Western Americana, Beinecke Rare Book and Manuscript Library

Yellowstone much more accessible and comfortable to would-be travelers. Promotional campaigns by the Northern Pacific and the Yellowstone National Park Improvement Company, which ran the hotel, featured the development of guidebooks and advertising in newspapers and magazines. Each also organized a grand excursion to Yellowstone for assorted guests, including government officials, foreign dignitaries, journalists, and others who might publicize the park or invest in their companies.[21]

In many ways, though, the park was not prepared for the onslaught of visitors. As excursionists quickly discovered, the physical infrastructure of the park was largely undeveloped. Where roads existed, they were primitive and inadequate for the carriages that the Improvement Company hoped to use to shuttle tourists to different parts of the park. The cabins and tents that served as accommodations in various places were likewise of poor quality and

provided little comfort. While the opening of the National Hotel promised to provide Yellowstone with a first-class hotel that featured electric lighting, fine dining, and private baths, tourists more often expressed disappointment with the new hotel. Shoddy construction, mechanical mishaps, and high fees led to many complaints during its inaugural season. Because construction delays postponed its opening until early August, the business ran a large deficit in its first year that contributed to the Improvement Company's eventual bankruptcy and the hotel's sale two years later.[22]

These problems mirrored the larger administrative difficulties that the park was confronting at this moment in its history. Although Americans could point with pride to their new national park, few had a clear sense of what it was or how it should be used or managed. Whereas Arthur's trip was billed as an opportunity for the president to get away from Washington for a fishing vacation, it

happened at a time when certain fundamental issues regarding the park were being debated locally, nationally, and within the halls of Congress. What rules would regulate the manner in which visitors experienced the park? Who should manage it, and what type of legal authority and financial support would they have in its oversight? Should the park's boundaries be expanded or perhaps reduced? Perhaps most importantly, what role should private enterprise play within a public park? Although some answers already existed, the only consensus regarding these questions was that the present situation was inadequate to meet the increasing number of visitors and the growing demands by a host of different constituencies. While Arthur never seems to have publicly entered the debate about the park's future at this time, several members of the president's Yellowstone party, including its two principal organizers, General Sheridan and U.S. Senator George G. Vest of Missouri, had been outspoken in the past and would continue to work towards reforming the park's management.

Sheridan had traveled through the park during each of the two previous summers as part of his reconnaissance work as commander of the U.S. military in the West. The fact that he made Yellowstone his destination during these travels indicates the level of interest he had in the park. From these trips he came away outwardly concerned about poaching, vandalism, and the ineffectiveness of the park's civil administration. As he wrote in his official report upon his return in 1882, Yellowstone "has been now placed in the hands of private parties for money making purposes, from which claims and conditions will arise that may be hard for the government and the courts to shake off." In addition, hunters continued to shoot game in the park. "As many as four thousand elk were killed by skin hunters in one winter, and that even last winter, in and around the edges of the park, there were as many as two thousand of these grand animals killed, to say nothing of the mountain sheep, antelope, deer, and other game slaughtered in great numbers." Given Sheridan's concern over animal populations, his primary recommendations were the extension of Yellowstone's boundaries and additional military support to guard the park from illegal

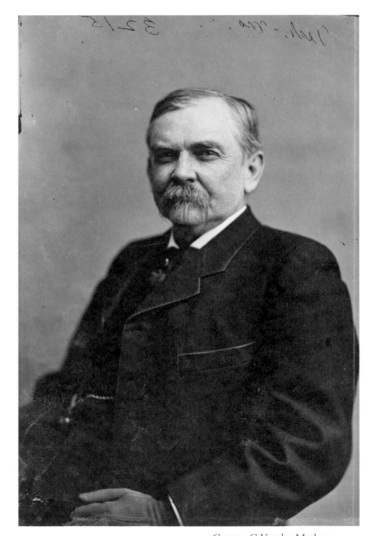

George G. Vest by Mathew Brady Studio, modern print from glass plate negative, c. 1875. Brady-Handy Collection, Library of Congress, Prints & Photographs Division, Washington, D.C.

hunters. Under his proposed expansion, the park would roughly double in size, with vast new stretches of land to the east and to the south being added. He explained that "this extension would not be taking anything away from the people, as the territory thus annexed to the park can never be settled upon." Furthermore, if park officials could not adequately protect the park, he declared that, "if authorized to do so, I will engage to keep out skin hunters and all other hunters, by use of troops from Fort Washakie on the south, Custer on the east, and Ellis on the north, and if necessary, I can keep sufficient troops in the park to accomplish this object, and give a place of refuge and safety for our noble game."[23]

What likely prompted Sheridan's outcry about "private parties" in the park was not simply reports about the persistent problem of illegal hunting. Upon leaving the region late that summer, he learned that Assistant Secretary of the Interior Merritt L. Joslyn had signed on September 1, 1882, an exclusive concession contract with Rufus Hatch, the president of the Yellowstone National Park Improvement Company, that would permit Hatch to develop various private businesses at seven different sites in the park. Nearly 4,500 acres would be set aside for these ventures. Furthermore, Joslyn had agreed to permit the Improvement Company to use as much timber, water, and coal in the park as it pleased. For this privilege, Hatch would pay two dollars per acre annually for the duration of the ten-year lease. Officials at the Interior Department recognized that accommodations needed to be provided for the growing number of visitors and believed that Hatch, a wealthy New York businessman and investor, had the resources and wherewithal to build the infrastructure that the park sorely lacked. This unexpected news greatly upset Sheridan.

When word of Hatch's contract became public, a storm of criticism rained down from many quarters. Locally, Yellowstone superintendent Patrick Henry Conger and Montana territorial governor John Schuyler Crosby took the lead in opposing the deal. Although Conger supported internal improvements in the park, he feared that the presence of such a significant private business would undermine his authority. As he wrote his boss, Secretary

of the Interior Henry M. Teller, in September, "they ask to cover entirely too much ground."[24] Crosby's objections were centered on his concern that the park's wildlife would be adversely affected by such development and on his disapproval that the ownership group was located far away in the East. Like Sheridan and Senator Vest, Crosby favored a bigger park, and he corresponded with both men over the next six months endorsing the idea that the park was "our future nursery of game" and urging that efforts be made to curtail the power of "speculative individuals."[25] That spring Sheridan asked Crosby to join Arthur's Yellowstone excursion, an invitation that he heartily accepted.

In the East, the Hatch contract precipitated an even larger firestorm. There two men in particular stepped forward to contest it: Senator Vest and *Forest and Stream* editor George Bird Grinnell, a native New Yorker who was one of the period's leading conservationists. Their belief that the park was under assault by commercial interests led them to initiate a protracted debate about Yellowstone's future that began before and continued well beyond the president's trip. Having read Sheridan's report and having learned of Hatch's contract, both men were moved into action. As a member of the Committee on Territories, Vest called in December for an investigation of the deal and for a study of the park's management. He also got up in front of Congress and spoke passionately about Yellowstone's larger significance. "The great curse of this age and of the American people is its materialistic tendencies," he explained and then continued:

> Money, money, l'argent, l'argent, is the cry everywhere until our people are held up already to the world as noted for nothing except the acquisition of money at the expense of all esthetic taste and of all love of nature and its great mysteries and wonders. I am not ashamed to say that I shall vote to perpetuate this Park for the American people. I am not ashamed to say that I think its existence answers a great purpose in our national life. . . . There should be to a nation that will have a hundred million or a hundred and fifty

million people a park like this as a great breathing place for the American lungs.[26]

A week following Vest's speech Grinnell published in *Forest and Stream* the first of what became almost weekly diatribes, which continued more than a year, against those whom he perceived as abusing Yellowstone. Like Vest, he endorsed Sheridan's park expansion and the idea that the military was best suited to oversee the park. He condemned the Yellowstone National Park Improvement Company for its "park grab" and Secretary Teller for his pro-development stance. By contrast, Grinnell's vision was that the park was primarily a refuge for large game. He wrote that winter:

> The time is coming when the large game of the West will no longer exist in any considerable numbers. . . . The park is overrun by skin hunters, who slaughter the game for the hides, and laugh defiance at the government. The park is a pleasant summer resort for the Secretary of the Interior, whoever he may be, who makes his jaunt thither, wonders greatly at what he sees, and returns to Washington. The curse of politics has entered into the management of the reservation, and the little money appropriated for its maintenance is wasted by incompetent and ignorant officials. It is leased by private parties, who desire to make a peep show of its wonders. . . . There is one spot left, a single rock about which this tide will break, and past which it will sweep, leaving it undefiled by the unsightly traces of civilization. Here in this Yellowstone Park the large game of the West may be preserved from extermination.[27]

Hatch fought back against their charges. As the leading stakeholder in the Improvement Company, he had committed $500,000 to the construction of the National Hotel, and he had every intention to see that work begin at once. With the completion of the Northern Pacific Railroad in sight, he wanted to be ready to receive guests the next summer. Traveling to Washington in late December, Hatch met with congressional supporters and held

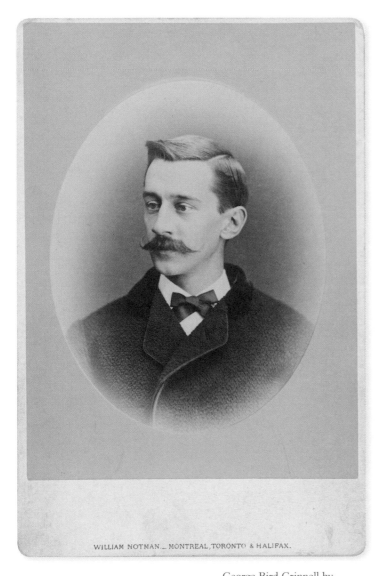

George Bird Grinnell by William Notman, albumen silver print, c. 1880. National Portrait Gallery, Smithsonian Institution

a special dinner for the press, where he defended the Improvement Company and his own vision for the park. His "Letter to the Editor" in the *New York Times* on January 4, 1883, challenged his detractors and invited the public to review the contract for themselves:

> There seems to be as dense an amount of ignorance in the public mind about the proposed plan for the opening of the Yellowstone National Park to tourists as there actually is concerning the geography, topography, and general character of the park itself. . . . The leases expressly provide that nothing contained in them is to be construed as conferring on the lessees any right to "restrict or prevent or in any way interfere with the free and unrestrained access of the public to any of the curiosities, wonders, and other points of interest to visitors within said park." . . . If you think there is anything in the documents that is unjust to the public, or that indicates a "grab" or "steal" or anything that the people of our company should be "ashamed" of, I have no objection to your pointing it out editorially, and condemning us.[28]

In the meantime, he ordered that work begin immediately on the hotel's construction.

For the next several months the two sides went back and forth with their charges. In the process, what began as a relatively small matter had become a national debate about the park's future. Various authorities and newspapers weighed in, including *Harper's Weekly*, which concluded that Hatch's goal was "of course, to make the largest possible amount of money out of the Park in the shortest possible time. That object is altogether inconsistent with the purpose of preserving the Park as a public pleasure-ground for us and for posterity, which animated Congress in reserving it from settlement. The lease would be sure to result in spoliations and desecrations from the effect of which the Park would never recover."[29] Although Hatch fought back, attacking Sheridan, Crosby, and others in print, the forces aligned against him proved too much. Bowing to pressure, Hatch ultimately agreed to renegotiate his lease. On

March 9, 1883, he signed a new ten-year contract that would allow the construction of the National Hotel to continue. However, the amount of acreage on which he could operate was greatly reduced. Further, he would no longer have exclusive rights to run businesses in the park. Ever the businessman, though, he negotiated that his two-dollar-per-acre lease fee would remain the same.

The crisis over the Yellowstone National Park Improvement Company also prompted government officials to look anew at the park's management. As this debate had made evident, Yellowstone needed greater protections and more resources. That winter both the U.S. Secretary of the Interior and the Congress acted. In January Teller wrote Superintendent Conger informing him that new stricter regulations regarding hunting, fishing, and lumbering would go into effect immediately. In particular, no hunting of any kind would be permitted in the park. Congress backed the rules and, in its annual appropriations bill passed in March, made available a new level of funding for the park. Whereas during the previous year the park had received a mere $3,180 to underwrite its operations, Congress made $40,000 available that spring.[30] These funds would be divided into two new categories: administration and protection, and construction and maintenance. This appropriation would permit the superintendent to hire a group of assistants whose primary responsibility would be the enforcement of these new regulations. While Hatch had urged Teller the previous fall to request $500,000 from Congress for improvements to Yellowstone's infrastructure, the new bill did allocate some money for the first time for new construction and maintenance.[31] What did not pass, however, was the extension of the park's boundaries, which was a great disappointment to Sheridan especially. In the year ahead, he would continue to fight for this extension.

All things considered, the new Yellowstone bill was hailed as a victory for conservationists. During the Congressional debate a range of proposals were brought forward, including a plan to survey the park and sell it as other public lands are sold—an idea proposed by U.S. Senator John James Ingalls of Kansas, but ultimately rejected. With passage of the bill completed, Senator Vest emerged

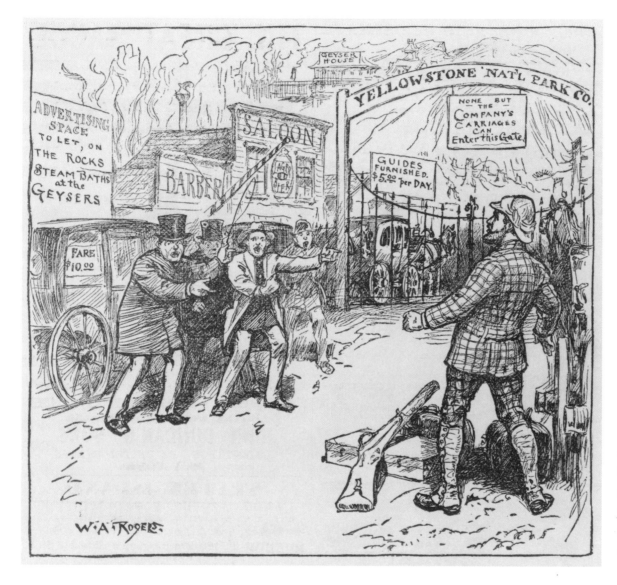

Desecration of Our National Parks by William A. Rogers, woodcut engraving in *Harper's Weekly*, January 20, 1883. Library of Congress, Prints & Photographs Division, Washington, D.C.

as the champion of the day. In *Forest and Stream* Grinnell reprinted the legislation in its entirety and editorialized at length about the significance of the victory:

> The Park is at present all our own. How would our readers like to see it become a second Niagara—a place where one goes only to be fleeced, where patent medicine advertisements stare one in the face, and the beauties of nature have all been defiled by the greed of man? It is a boast of the day that this is a practical age, and its motto seems to be, "Put money in thy purse." Get money; get it—honestly, if you can—but get it. Sacrifice everything to this hunger for lucre. Set Niagara to turning millwheels, build your manufactories over the geysers, for in them you have perpetual motion. Cut up your parks and sell them

for farms or for building lots, as the case may be. The man whose pockets are to be filled will not say a word against the work of destruction. The progress of this spirit must be checked; and for having interfered to save the Park from the monopolists, we thank you, Senator Vest.[32]

It was during the height of this debate that Sheridan and Vest first discussed the idea of organizing an excursion of notable government officials to Yellowstone. With much about the park's future still undecided, it seems that they were especially interested in approaching the president with an invitation. Clearly, they hoped to convince him of their vision for the park. While the president had been a close political ally of former U.S. Senator Roscoe Conkling of New York, a friend of Hatch's and a prominent member of the Improvement Company's board of directors, Arthur had not weighed in publicly during the Yellowstone debate. Was he silently supporting the development camp, or was he more closely aligned with the conservationists? Sheridan and Vest wished to find out and thought that a trip to the park would provide an ideal opportunity. On January 31, 1883, Sheridan responded to an earlier letter from Vest: "If you and the President would like to go to the National Park this coming summer, I will place myself at your service and will only be too glad to do so. I have all the means on hand to take you in a comfortable manner without making any fuss about it. . . . The first of August would be the best time to go. I will be in Washington next week for a few days and will pay my respects to you, when I can explain in detail on this subject."[33]

Throughout the spring Sheridan and Vest prepared for the proposed trip and compiled a list of guests who might join them. In April Sheridan wrote Vest and provided him with an outline of the journey: "On leaving Washakie, we will bid adieu to civilization and in fifteen or sixteen days will reach the Upper Geyser Basin. This distance will be made in easy marches and we will encamp on a trout stream every day, and those who want to hunt, after two or three days out, will find plenty of game. . . . On your return, my dear Senator, I am sure you will feel as if your longevity has increased twenty years."[34] Although Arthur did not

commit until late June or early July, Sheridan and Vest were busy recruiting others to join them. By the late spring, the party was to include the following: Secretary of War Robert Todd Lincoln (Sheridan's boss who was to have accompanied him during the 1882 Yellowstone expedition, but had to cancel at the last minute), Montana's territorial governor John Schuyler Crosby (a recent champion of Sheridan's park expansion plan), and U.S. Senator John Alexander Logan of Illinois (an influential senator and close friend of Sheridan's). In addition, Sheridan's brother Michael would serve as the "Military Secretary" for the party, two military officers would act as aides-de-camp, and a doctor would also join them. Finally, Sheridan expressed to Vest that both he and Arthur were permitted to invite one guest. His desire was to limit the formal party to twelve participants.[35]

Although Congress had passed a significant increase in Yellowstone's budget and the crisis over the Improvement Company's lease had been resolved, there was still much discussion about the park in the months leading up to the trip in August. Indeed, the contest over what the park would be and how its lands would be used continued to escalate. New federal dollars permitted Superintendent Conger to initiate a small road improvement project in May, though the question of how people would move through the park remained largely unsolved. Rumors circulated that officials at both the Northern Pacific Railroad and the Yellowstone National Park Improvement Company were interested in building a railroad within the park not only to transport tourists, but also to carry silver and gold bullion from the mines that had recently been opened up in Cooke City, Montana, a community just outside the northeast section of the park. Earlier that spring local businessman George O. Eaton had brought together various mining claims to form the Republic Mining Company, and Eaton was one among many who were now pushing the idea of a branch rail line to Cooke City. Due to geography, though, the only route for such a line was through the park. Many Montana legislators and local citizens favored the new rail line. As one local newspaper reported in September, "the host of influential persons, great and small, who have visited the park this

summer, were not induced to come merely to advertise the park. Other plans are in the process of development and a railway within the park is one of them." Back east, however, such plans received much less enthusiasm, and once again Grinnell, Vest, and others lined up to fight them.[36]

As Eaton and others were exploring this possibility, the Northern Pacific Railroad was rushing to complete its main transcontinental line by late summer. When news of the president's trip became public, company officials reached out to Arthur with an invitation to join them at the festivities in Gold Creek, Montana Territory, to celebrate the laying of the final rail. Only a week prior to Arthur's departure from Washington, Roscoe Conkling wrote Arthur with the railroad's invitation. Other hurried notes followed, though Arthur replied to the company's president Henry Villard

on July 28 that "while it would afford me much pleasure to attend the celebration of this great national undertaking, but I think it is doubtful whether the arrangements for my trip to the Yellowstone Park will permit me to be at the point named at the date fixed for the opening." He recommended that Secretary Teller attend in his place, but left open the possibility of joining the festivities at some other point along the new line.[37]

In the meantime, Villard moved forward with his plans to organize a large party of government officials, foreign dignitaries, and newspaper reporters to venture west to attend the railroad's completion. While Villard had not secured Arthur's presence at Gold Creek, he had recruited ten senators, seven governors, and nine army generals to join an excursion that numbered 332 people when it left New York in forty-three railroad cars in late August.

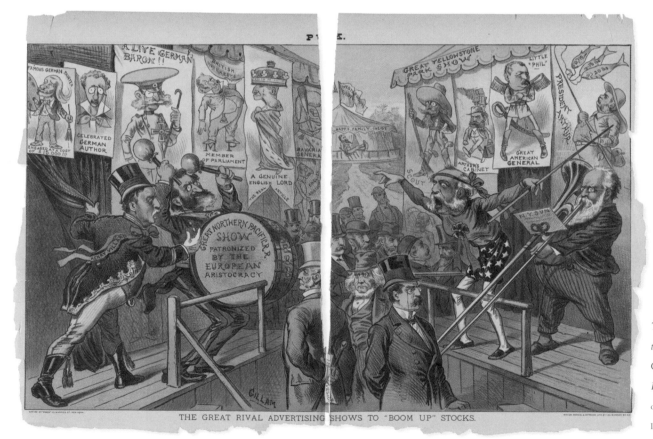

THE GREAT RIVAL ADVERTISING SHOWS TO "BOOM UP" STOCKS.

The Great Rival Advertising Shows to "Boom Up" Stocks by Bernhard Gillam, woodcut engraving in *Puck*, September 5, 1883. Library of Congress, Prints & Photographs Division, Washington, D.C.

Former president Ulysses S. Grant also signed on for a tour across the continent that lasted six weeks and ultimately cost Villard nearly $200,000. Such an extraordinary investment of time and money was a calculated and somewhat desperate gamble. Earlier in the summer Villard had learned that the company needed an additional $14 million to complete the mainline. Through a highly visible celebration, Villard hoped to recruit investors to provide this capital. More generally, he also sought to sell the new transcontinental line to the American public and to solidify its centrality in the opening up of the West to settlers, business leaders, and tourists. Situated not far from their tracks, Yellowstone was an important element in the railroad's larger plan. By transporting thousands of visitors every year to the park, the Northern Pacific saw itself as vital to Yellowstone's future. However, though many welcomed the ease of rail travel, the influence of this company concerned those who worried about the park's ability to remain independent.[38]

In addition to issues concerning the Northern Pacific, there remained related questions about the role that the Improvement Company—and private enterprises more generally—would play in the park. Conkling's letter to Arthur was written as he embarked on his own trip to Yellowstone. Traveling in Henry Villard's private rail car two months before the Villard excursion was set to depart, Conkling headed west to oversee the final preparations prior to the opening of the National Hotel. As an influential member of the Improvement Company's board, he went out ahead of Hatch, who remained back east to complete the final details of his own trip to the park, which he was arranging for more than sixty journalists, business leaders, and other luminaries. Given that the National Hotel was being built largely on credit, the future of Hatch's Improvement Company depended on the success of this trip, which was set to leave New York in mid-August—two weeks before the departure of Villard's party. Hatch had originally envisioned a hotel at Mammoth Hot Springs that would accommodate 800 guests; however, construction delays and financial setbacks greatly reduced the scale of the hotel that opened in early August. Hatch

understood well his predicament and blamed Congress in private correspondence with Carroll T. Hobart, the company's vice president and general manager.[39] Yet, if investors came forward to provide fresh capital, the National Hotel that he envisioned might still be realizable.

Not surprisingly, much effort and attention to detail were paid to ensuring this party's success. Like Villard, Hatch was footing all expenses and worked to provide a first-class trip. By sending Conkling to Yellowstone early, Hatch could be assured that everything possible was being done to ready the new hotel. He must also have thought that Conkling could persuade Arthur to look favorably on the enterprise and perhaps even to endorse it when he passed through the park. Arthur and Conkling had been longtime friends from their days as part of the "Stalwart" faction of the Republican Party. Although Arthur tried to distance himself from this group in order to demonstrate his political independence during his first year in the White House, he had reached out to Conkling and nominated his friend for the Supreme Court, a post that Conkling ultimately declined. Hatch and Conkling hoped that the president might reach out again to show his support for the Improvement Company. Hatch organized the schedule in such a way that their party would arrive at Mammoth Hot Springs precisely at the same time as the president's. Preparations for a reception were in the works, and efforts to connect with both Arthur and Senator Vest were being made. The urgency of the situation revealed itself in a letter from Carroll T. Hobart to his wife Alice in the days leading up to the president's arrival: "Monday the President and party arrive. In this last party is Sen. Vest and I feel that he must be Captured. So far we have succeeded beyond our highest expectations. Everyone that sees what we are doing all leave on their endorsement of our Company."[40] Given Vest's influence on all matters related to Yellowstone, Hobart identified the senator as vital to their future prospects.

While the support of Arthur and Vest would be invaluable, Hatch was courting as many potential supporters as possible. In early July he learned that the famed New York minister Henry Ward

Rufus Hatch (standing with hand in vest) and Yellowstone Excursionists at Fargo, Dakota Territory by Frank Jay Haynes, modern print from glass plate negative, 1883. Montana Historical Society

Beecher was planning a cross-country lecture tour, and that he and his wife intended to travel to the Pacific Northwest and California via the Northern Pacific Railroad. Hatch wrote Hobart at once and explained, "I want you to give him a royal time of it while he is in the Park. . . . If we should ever want anyone to lecture for us, either in the United States or in Europe, Henry Ward Beecher is the man to do it, and he is the only man that I know of who could do anything like justice to the wonders of the Park."[41] Ultimately, Beecher never wrote anything of note about the park. Hatch and others at the Improvement Company were, nonetheless, intent on publicizing the park to a wide national audience—a fact that was met with a certain skepticism, especially among area residents. Although not entirely opposed to bringing more business to the

region, local leaders understood well Hatch's intentions. As an editorial in the Livingston, Montana, newspaper declared, "If he was a resident of the Yellowstone valley he would be called a 'rustler,' and would be clearly entitled to that honorary distinction. No better proof of his claim to that title can be adduced than the present expedition upon which he is engaged." Described as "the grandest advertising scheme ever inaugurated," the Hatch excursion did not fool those who lived closest to the park.[42]

In the waning days of July, as President Arthur prepared to commence his trip, much was on the line for many with interests in Yellowstone and the West more generally. The financial investment that Henry Villard had made in the Northern Pacific Railroad and that Rufus Hatch had made in the Yellowstone National Park

Improvement Company hinged on their ability to draw patrons. Given the precarious nature of their capital-intensive projects, they required a positive reception in short order. The president was not going to make or break these enterprises, but the success of his trip and his endorsement of them would go far in their future success. While Arthur's main concern was the chance to get out of Washington, Villard and Hatch understood that his journey was potentially much more significant. Likewise, to those who favored conservation and endorsed Sheridan's plan to enlarge the park, the trip was equally important. After a decade of benign neglect, Yellowstone was at a crossroads in its history, as two distinct and not necessarily complementary visions for the park struggled to be realized.

As others hurried to ready themselves, George Bird Grinnell wrote most eloquently about the stakes of the president's trip. In an editorial entitled "Seeing the Yellowstone Park" published in *Forest and Stream* four days before Arthur's departure from Washington, he wrote:

The important point of the excursion will be that members of the Government, whose influence should be strongest in shaping legislation on this important subject, will be able to see for themselves a part of the needs of the Nation in respect to the Yellowstone Park. It is impossible, of course, in a hasty trip across such a wide area, to appreciate all that is required in the way of provision for the protection of the Park and its interesting features, whether organic or inorganic, but intelligent men cannot fail to acquire much useful knowledge, especially when they go accompanied by one who is so familiar with a considerable portion of the reservation as is Gen. Sheridan.

Lending his support to the campaign for the park's expansion, Grinnell concluded by remarking that "we trust that the need of such enlargement will be so clearly seen, that a recommendation concerning it may form a part of the next message of the President to Congress . . . The gentleman who are about to visit the Park are incurring responsibilities in the matter which we are glad to see them assume, for we are confident that this pleasure-trip will, next winter, in Washington, bear abundant fruit."[43]

———•———

The album that Frank Jay Haynes assembled begins with a photograph of Fort Washakie—an image likely taken several days before President Arthur's arrival there. In many respects that military outpost is an appropriate place to begin an accounting of the president's trip, for it was here that their travel overland on horseback began. Furthermore, it was here that Sheridan had arranged to meet the seventy-five-man military escort that would accompany the party for the next three weeks. Located on the Wind River reservation and named for the renowned chief of the Shoshones, the fort was also the place where Haynes joined the party and where the president first encountered

and met with a large group from two Native American tribes. On the day they left the fort, Arthur did his first fishing. Indeed, the president's western trip started at Fort Washakie.

Yet, Arthur had already been away more than a week when his party finally arrived at Fort Washakie. Having been in New York the week before his departure—where he purchased $49.62 worth of fishing equipment from Abbey & Imbrie, including a new rod, reel, and eighty trout flies—he departed Washington, D.C., on a special train at 4 A.M. on Monday morning, July 30, 1883. Among the guests traveling with him were Secretary of War Lincoln, Senator Vest, and Surrogate Rollins. Senator Logan was scheduled to attend as

well, but he had backed out three weeks earlier because of an illness. At least one newspaper hinted, though, that he may not have wanted to travel with the president, because of his own ambitions to seek the White House during the following year's presidential election.[44] In Logan's place, General Anson Stager, an old friend of Sheridan's from Chicago, joined the party. Vest was permitted to bring a guest and he had invited his son, George G. Vest, Jr.

Although the president was going to be away for six weeks, the group was on a rigidly defined schedule, and no time was permitted for extra excursions. That said, there was presidential business to attend to on the journey west. After making a brief stop at the Greenbrier resort in White Sulphur Springs, West Virginia, the Chesapeake & Ohio train sped towards Louisville, Kentucky, where Arthur participated in the formal opening of the Southern Exposition. In Louisville, General Sheridan and Michael Sheridan joined the party, having traveled south from Chicago to join the festivities there. Arthur's public speeches were almost always short and rather perfunctory, and in Louisville he once again lived up to his reputation for brevity. Despite much effort by local organizers to celebrate Arthur's visit, including a special lunch for him at the former residence of statesman Henry Clay and the mounting of a large portrait of the president to the headlight of the train that carried him, the president did relatively little to reach out to the crowds that gathered to greet him in Louisville and in communities all along his route west.[45]

On August 2, they left Louisville and headed to Chicago, where again a large group of admirers had gathered to greet him. After making a brief statement, he retired to a private reception with the mayor and other local leaders at the Grand Pacific Hotel perhaps, as some newspapers speculated, to meet with those who might support his possible run for the White House.[46] Yet, he was on a tight schedule, and by noon of the following day, the president and his party were back in their railroad cars and headed west towards Omaha, Nebraska, and then to Cheyenne, in Wyoming Territory. While the newspapers believed that he would make an appearance in Omaha, the train passed through without stopping;

in Cheyenne, he stopped long enough to wave and to greet a few local officials. Once they reached Green River, Wyoming—270 miles west of Cheyenne—the train trip was over. After spending a day there to rest, they left Green River on Monday morning, August 6, traveling overland for two days in three stagecoaches headed towards Fort Washakie, which was 101 miles away. Arthur was excited to finally get off the train and rode much of the way sitting outside next to the driver.

In the late afternoon on the following day, the group reached the fort. Haynes wrote his wife Lily about their arrival: "The President's Party came here last eve. Today has been a big day here. The Indians have been in full costume mounted on ponies. They had a sham battle against the Cavalry. Both were armed but with blank cartridges. It made a fine sight . . . I shook hands with the Big Chief, General Sheridan and others. We start for the Park tomorrow at 7 o'clock."[47] While he had started taking photographs prior to the party's arrival, Haynes went to work recording the day's proceedings. Yet the subject that most fascinated him was not primarily the president and his party, but rather the Shoshones and Arapahoes on the Wind River reservation who had gathered to greet President Arthur. As Haynes reported to Lily, a large delegation, led by Washakie of the Shoshones and Black Coal of the Arapahoes, came forward to meet and to exchange presents with the president. Arthur received several gifts, including a pony that was intended for his eleven-year-old daughter, Ellen. He then reciprocated by presenting blankets and saddles to various tribal leaders. He also used the occasion to commission Washakie as an official military scout in recognition of his distinguished service on behalf of the U.S. Army. At this time a ceremonial dance was performed. As Haynes mentioned, a sham battle—not unlike those that William Cody was then popularizing in his new show "Buffalo Bill's Wild West"—was also enacted.

But the president's meeting with the Shoshones and Arapahoes was not simply pageantry. There were also specific topics to be discussed with tribal leaders, most especially the proposed idea to implement an allotment land-ownership system on the Wind

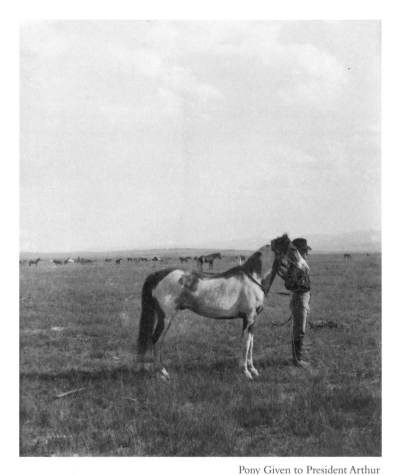

Pony Given to President Arthur at Fort Washakie by Frank Jay Haynes, modern print from glass plate negative (one half of a stereograph), 1883. Montana Historical Society

River reservation. Many government officials during this period encouraged tribes to see land as private property, rather than holding lands in common. As a member of the Senate Committee on Indian Affairs, Senator Vest met with Washakie and Black Coal then to urge them to accept this change, which non-Native reformers believed would accelerate their peoples' larger acculturation into American society and ensure their future welfare. The president favored the allotment land-ownership system and supported legislative reform of U.S. policies concerning Native tribes. Several months after his return from the West, he would urge greater government spending on Indian education, a proposal that was never adopted. Yet most tribes, including the Shoshones and Arapahoes, opposed this new system. While Arthur was not successful in getting this legislation passed during his presidency, his successor, Grover Cleveland, was. In 1887, under the leadership of U.S. Senator Henry L. Dawes of Massachusetts, the General Allotment Act was passed, irrevocably changing a central tenet of Native American society.

In the album, Haynes's photographs and Sheridan's dispatches highlight this encounter with the Shoshones and Arapahoes. The pageantry was a dramatic subject, and reports about negotiations with the tribes served to heighten the importance of the trip itself. Apart from this moment, though, Native Americans figured only rarely in the larger account. Michael Sheridan does mention that his brother recruited several Shoshone and Sheep Eater guides to assist in directing the party to Yellowstone, a practice that General Sheridan followed during his two previous expeditions to the park. Although twenty-six different tribes had maintained a historic association with the lands in and around Yellowstone, a concerted effort was then being made by the military and other officials to remove them from the region and to render their presence a historic footnote. A band of the Shoshones, the Sheep Eaters had arguably the most significant year-round connection to the lands that became a national park in 1872. However, by the early 1880s Yellowstone superintendent Philetus W. Norris had ostensibly outlawed them and all other Native peoples from the region. With these groups

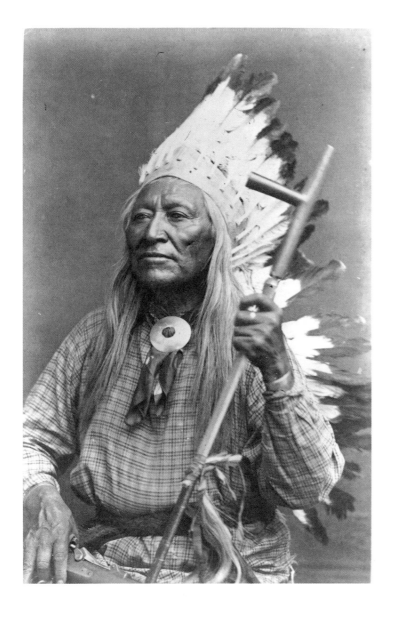

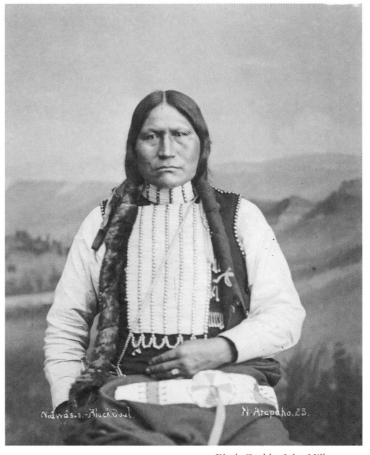

Black Coal by John Hillers,
albumen silver print, c. 1880.
National Anthropological Archives,
Smithsonian Institution

Washakie by Baker and
Johnston, albumen silver print,
c. 1880. National Anthropological
Archives, Smithsonian Institution

relocated to different reservations well beyond the park, Yellowstone became the "uninhabited" landscape consistent with the unfolding myth that many non-Natives held about this place.[48] Haynes and Sheridan refer at times to the historic presence of Native Americans, yet reaffirm this unoccupied dreamscape in their photographs and written dispatches.

Over the next three weeks, the episodes that take center stage for Haynes and Sheridan concern the party's daily progress overland and the fishing exploits of Arthur and others. Departing Fort Washakie on horseback on August 9, the party ventured northward towards the park largely on their own, or so it seemed from Haynes's photographs and Sheridan's dispatches. While the large military

escort under Captain Edward M. Hayes and the inclusion of 175 pack animals to carry supplies are introduced at the outset, they fade from the scene—at least in the album. With these groups increasingly outside the frame, the beautiful, yet rugged wilderness and the heroic nature of Arthur's journey become the prevailing themes of the album. Except for the erroneous stories about their trip from certain newspapers and outside reports they received, there seemed to be few disturbances, accidents, or arguments. As Sheridan frequently commented, all were in good health and enjoying themselves immensely. In particular, the fishing was everything they hoped, and President Arthur and Senator Vest routinely returned to camp with the greatest number of fish for the day. Predictably, Haynes was not slow to capture the results of their fishing adventures. Overall, the album foregrounds the trip's great success.

There is little reason to doubt the general accuracy of Sheridan's upbeat report. Later accounts of the trip also highlight the good time seemingly enjoyed by all. As in the album, these articles focus repeatedly on the fishing prowess of the president. One particular story related by Senator Vest exemplifies this coverage. The account begins with Vest spotting a big fish in a distant pool and preparing to cast in that direction:

> Turning to the president I said: "Here you take that trout in." "Oh, no," he replied, stepping back, "this is the Sabbath. I couldn't think of handling a rod today." I stepped up to the brink of an overhanging rock and made a very poor cast. I pretended that I could not get the line out. . . . After several more feints, I again turned to the president and said. "I am not able to cast that far and will have to get you to send that fly over for me." He took hold of the rod and after one or two efforts put the fly just in the right place. It was a long cast. In an instant the noble trout darted for the bait, and with a skilful turn of the president's wrist he was hooked. "Here, Vest," shouted Arthur, holding the rod toward me, "you must land him, for I will not." I took the rod and in about twenty minutes landed the trout, which weighed three pounds.[49]

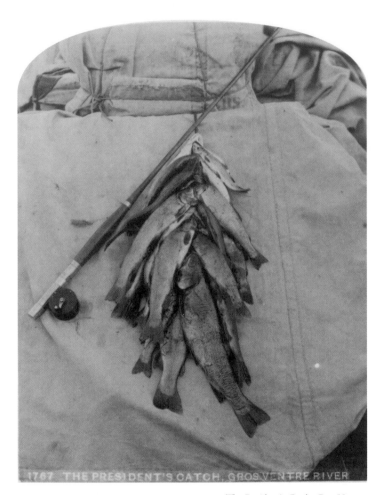

The President's Catch, Gros Ventre River by Frank Jay Haynes, albumen silver print, 1883. Library of Congress, Prints & Photographs Division, Washington, D.C.

This anecdote epitomizes their regard for Arthur, but also hints
at the lengths to which his travel companions went to flatter him.
Little attention is paid in these accounts to the larger issues regarding
Yellowstone and its future. From the start Sheridan and Vest saw this
excursion as an opportunity to educate the president about the park,
yet discussions about their long-standing concerns and their possible
efforts to line up his support are largely absent from the record of
the trip. Set amidst the majestic Wind River and Teton Ranges,
the narrative is largely an idyll, rich with expressions of peace and
contentment.

Although most participants enjoyed their time in the wilderness
with the president, it is clear from their letters and other private
accounts that different members of the party did experience a
few relatively minor mishaps, which do complicate the album's
unflaggingly positive tone. For instance, only a day out from Fort
Washakie, Haynes almost lost a large portion of his photographic
supplies when "a rope broke as we were going up a steep hill and the
Camera and plateholder box went off of the rear of the pony." As he
recounted to Lily, the horse "began to kick and jump but he was so
mixed up amongst the outfit and ropes that it was hard to free him.
When the dust cleared away, fortunately nothing was broken and we
unloaded him and got back safe to camp." Haynes also admitted that
he may have miscalculated and brought too few photographic plates
with him. "It's a big outfit to carry around but I am getting a great
many orders already. I expect that we will get more dollars out of
the Big Views than from the small ones. . . . If I had about 60 large
plates instead of 35 I would like it better. However, I am taking it
slow and sure."[50] This shortage of supplies proved to be unfortunate,
for by the time the party reached Yellowstone Haynes had only
three large plates and less than a half-dozen small plates left. As a
result, the photographic coverage of Arthur's time in the park was
very limited. In the album, Haynes ended up including twenty-
three small-format views of famous landmarks in the park that he
had captured during the two previous summers. He also selected
six other small-format views taken later that fall after Arthur's
departure. Haynes—and perhaps others in the president's party—

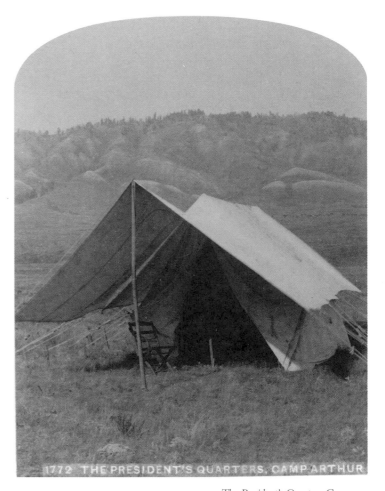

*The President's Quarters, Camp
Arthur* by Frank Jay Haynes,
albumen silver print, 1883. Library
of Congress, Prints & Photographs
Division, Washington, D.C.

were surely disappointed that his photographic supplies ran out at the climax of the trip.

Limited photographic coverage of their time in the park was a frustrating development. More unsettling to the group, however, were newspaper accounts that a "party of cowboys" had started towards Yellowstone with the intent of kidnapping the president. The *Chicago Tribune* had first reported about a rumored kidnapping attempt on the day following the group's departure from Fort Washakie. Because that paper had already misrepresented several aspects of the president's trip, the story was regarded with a degree of skepticism. Nevertheless, it registered with General Sheridan and those responsible for protecting the president. No other mention of a kidnapping plot occurred for two weeks, and Sheridan appears not to have revised his plans as a result of this one-time article. But on August 24, the *Wood River Times* in Hailey, Idaho Territory, reignited concerns when it published a fresh and more detailed article about the organization of a seemingly credible kidnapping plot. This report was soon picked up by newspapers throughout the nation. While the papers couldn't determine for certain whether the group was comprised of "Texas cowboys," "Arizona rustlers," or "a group of prospectors," the articles outlined the proposed plan. As the newspaper in Livingston, Montana Territory, reported, the "object of the expedition is to corral and capture President Arthur and party and spirit them away into the mountain fastness—to caves where they will be fed, but kept prisoners, while members of the party act as pickets to prevent being surprised and captured, and while negotiations for a ransom are being conducted." The paper suggested the party was comprised of sixty-five members, all with "repeating rifles and scalping knives," and that the kidnappers hoped "that half a million dollars or more can thus be extorted from the secret service fund and divided among the party on the principle adapted by the Italian banditti."[51]

Local law enforcement was ordered to look into the matter and to arrest anyone suspected of being involved in such a plot. As Arthur's predecessor had been killed by an assassin's bullet, precautionary measures were in order. An extra military escort was called up to accompany the president and his party during their final days in the park. Ultimately, to the relief of many, the story proved to be a hoax. In the days after the initial series of articles, commentators would make light of the kidnapping plot. As one local newspaper noted, the report read "very much like what is called in polite language a canard . . . started either to boom the paper in which it appeared, or to add another chapter to the interesting volume of 'Arthur records' produced by this trip of the chief executive to the Park."[52] Coupled with other fabrications and the prying nature of journalists in general, however, this episode lent further fuel to the president's long-standing abhorrence of the press. It also helps to explain Michael Sheridan's repeated negative remarks about journalists in his dispatches.

Publicly, neither the president nor anyone else in the party ever spoke about this hoax. While Sheridan expressed his ire at the press, he never mentioned it in his dispatches. Generally speaking, the trip went off without a hitch. Although they did endure several rainy days and were forced to backtrack on at least one occasion in order to find suitable range to feed the animals, the group was largely in good spirits throughout. Arriving at Mammoth Hot Springs on August 31, on schedule exactly three weeks following their departure from Fort Washakie, the entire party was not surprisingly fatigued, sunburnt, and needing a bath. One visitor who met the president there noted, "I flattered myself that he looked the shabbier and dirtier of the two as we sat side by side; besides the skin hung in strips on his nose, which did not improve his appearance."[53] Despite concern at the outset about Arthur's health, no clues have ever surfaced that indicate any type of medical scare. General Sheridan seems to have caught "mountain fever," according to one report, though everyone else returned in good health.[54] Neither long hours in the saddle riding over rugged terrain, nor freezing temperatures at night caused any public complaints. That positive atmosphere permeates both Haynes's photographs and Michael Sheridan's written account.

Yet, at least one argument—unmentioned by Sheridan—did happen that likely soured the trip's conclusion. On the last night

that the party was together in the park, a heated exchange between Michael Sheridan and the president occurred. Prompted supposedly by Arthur's reluctance to award Sheridan a promotion, the two men caused a commotion that spilled into public view. It's unclear whether a divide had previously existed between Arthur and Sheridan or whether these tensions extended to others within the party; indeed, this incident may well have been a unique, isolated occurrence.

The argument between the two men occurred on their final full day in the park. Having arrived at Mammoth Hot Springs and abandoned their horses, the group camped at a spot about a half-mile from the National Hotel. Hatch had wanted them to stay at the hotel, but Arthur favored a space apart from the crowds that were there. Once entering the park the president was repeatedly approached by visitors, and it seems that he wished to minimize his contact with the public—much to the consternation of some. As one visitor remarked, "it seemed churlish in the President to treat thus, not only his lieges, but the foreign guests. It is part of his office to be looked at. I was ashamed of him. He had secluded himself from all eyes."[55] Despite the president's obvious desire for privacy, Rufus Hatch was not going to allow this opportunity to pass without some type of exchange. Most likely on Hatch's insistence, approximately fifty hotel guests walked over to Arthur's camp in order to serenade him with a selection of songs.[56] After this concert, the group invited the president and his party back to the hotel, where Hatch had prepared a champagne and cigar reception. Most of these details are included in Sheridan's report.

What is not included is the story that George Thomas, a waiter at the National Hotel, later recalled in his reminiscences of the time when he worked in the park. According to Thomas, Arthur asked everyone to accompany him to the reception except Michael Sheridan. As he later remarked, "only Colonel Michael Sheridan was missing. He however entered later, in a state of inebriation, and without an invitation to be present on account of his dislike for President Arthur, who had failed to give him a promotion. As soon as President Arthur saw the intruder, he said: 'Please excuse me, gentlemen,' then made a dignified departure from the room." As he walked out, though, Sheridan "made a very uncomplimentary remark about the President. The party immediately broke up, leaving a dozen quarts of excellent Champagne and two boxes of cigars that were hardly touched."[57] No mention of these words ever seems to have surfaced in the newspapers, nor were there obvious repercussions from their exchange. Sheridan's final two dispatches, likely written the following day, do not reference the argument.

Haynes's photographs and Sheridan's account highlight many memorable places and moments, but—except for Sheridan's concerns about the press—they do not dwell on any underlying tensions or park debates. Of the 104 photographs in the album, seven include the president. In these views—all large-format images—Arthur is depicted as actively involved and at ease with his surroundings. Twice he appears crossing a river on horseback; at other times he is shown resting in camp or having lunch in the field. Although Haynes never photographed him with his fishing rod in hand, he did photograph the fish he caught. Sheridan's reporting matches the tone of Haynes's photographs. Both capture Arthur as the robust chief executive who is comfortably able to surmount the trials of the wilderness. Seemingly oblivious to any wider concerns, he marches to and through the park like a heroic western explorer. Missing in this account, though, are the larger issues about the park that were then being debated and the network of individuals and groups who were vying to have their vision stamped on the park itself. These issues had manifested themselves prior to the trip and would surface again before President Arthur was safely back at the White House.

Despite complaints before the journey from Democratic editors about the appropriateness of the president's excursion, the trip proved to be a positive experience for Arthur and others. The fishing was good, the scenery sublime, and, encouragingly, the president's health never seems to have declined. Furthermore, he received much positive publicity during the trip. The fact that Michael Sheridan's upbeat dispatches were at the heart of the coverage, of course, helped. Yet, independent coverage tended to favor Arthur as well. Also of note, articles about his potential run for the White House in 1884 appeared more frequently and painted a rosier picture for Arthur than ever before. As writer Mark Twain commented to a Chicago newspaper while the president was in the West, "I am but one in 55,000,000; still, in the opinion of this one-fifty-five-millionth of the country's population, it would be hard to better President Arthur's administration. But don't decide till you hear from the rest." Others concurred, and many believed that he was gaining in the court of popular opinion.[58]

Likewise, most who met Arthur or heard him speak during his travels were left with a positive impression. Although his desire for privacy and his brevity in public speaking disappointed some people, the public came away astonished by his modesty and approachability. For example, while attending Hatch's reception at the National Hotel, British journalist William Hardman found himself at "the President's right hand." Hardman later wrote about his encounter: "I found him a most courteous and agreeable man, ready to speak of public matters with less reserve than I should have anticipated. . . . I enjoyed a very pleasant chat with him for three-quarters of an hour, and I doubt if any other Englishman ever before had an interview under similar circumstances with any of the chiefs of the Great Republic across the Atlantic." Similarly, stopping briefly in Livingston, Montana, on his return journey, Arthur met with a crowd of local residents. In recounting the episode, the town reporter concluded, "President Arthur is a dignified, yet exceedingly affable gentleman, cordial without affectation, genial without undue familiarity . . . he is, in fact, an excellent representative of the people, over whom he has been called to preside as chief executive." Even his public speeches going west and coming back east tended to draw good reviews.[59]

On September 1, President Arthur and his party left Yellowstone through its north entrance. At the town of Cinnabar, in Montana Territory just outside the park, they began their railroad journey back east. Construction crews had finished the branch line from there to the main line of the Northern Pacific Railroad at Livingston the day before in time to carry the president homeward. Although Arthur had earlier declined Henry Villard's invitation to participate in the dedication ceremonies at Gold Creek, scheduled to occur a week later, railroad officials continued to work to secure his presence at some other point along the line. Telegrams inquiring about his availability reached the president in the midst of his overland journey. On August 20, while encamped on the Snake River in the shadow of the Tetons, Secretary Lincoln sent a telegram to Villard informing him that the president would "make a stop on the road at any point you may designate of sufficient length to see yourself and your guests."[60] Villard chose St. Paul, Minnesota, as a place to hold a ceremony with Arthur and his guests.

While Arthur did not wish to delay his travels back to Washington, he agreed to stop long enough to join in the preliminary festivities marking the completion of the new transcontinental line. Villard's large excursion, including former president Ulysses S. Grant, was then on its way west and their arrival in St. Paul was timed to coincide with Arthur's. Following a grand procession, complete with a series of wagons representing historic moments in Minnesota's past, several speeches were delivered. On this occasion, Arthur praised Villard and celebrated the region's future:

Coming to you from that marvelous region which has been sometimes called "The Wonderland of America," I have traversed the thousand miles which intervene along the rails of the Northern Pacific railroad. Nothing I have ever read, nothing I have ever heard, has so impressed me with the

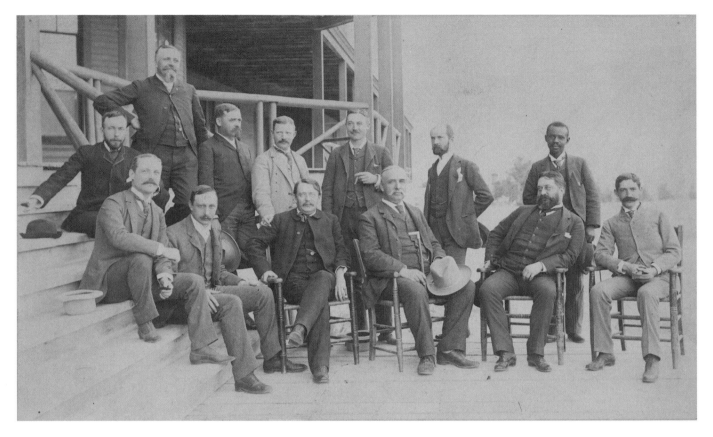

Henry Villard (seated center with hat on knee) and Others Gathered at the Ceremony Marking the Completion of the Northern Pacific Railroad by Frank Jay Haynes, albumen silver print, 1883. National Portrait Gallery, Smithsonian Institution; gift of Henry Villard

extent of the resources of the Northwest. It has convinced me that the importance of this enterprise, which we are gathered here to honor to-night, has not been over-estimated even by its most sanguine friends.[61]

After a "very pleasant though hurried banquet," Arthur's party proceeded amidst cheering crowds back to the railroad station.[62] While they made another brief stop in Chicago, where Arthur attended a reception at the chamber of commerce, the train wasted little time thereafter en route to Washington, arriving back at the White House on Friday, September 7. The president had been gone nearly six weeks. Over the next week Arthur mailed thank-you letters to various military officers on the trip and sent Michael

Sheridan a check for $246.30 for "my share of expenses of the Yellowstone trip."[63] Other non-military participants sent Sheridan checks for the same amount.

The day following Arthur's return to Washington, Villard and his guests gathered at Gold Creek—a small town west of Helena, Montana's territorial capital—to participate in the ceremony marking the official completion of the transcontinental line. Approximately two thousand people were in attendance to watch the final stretch of track being laid. As the railroad's construction had actually been completed two weeks earlier, this work was simply a reenactment. Nevertheless, such a show was important to Villard, who allowed a series of dignitaries, including Grant, to take a swing in driving home the final spike. Haynes was in attendance

that day, having left the president's party back in Yellowstone, and, with fresh supplies in hand, he took a series of views to commemorate the day's festivities. Likewise, numerous journalists were present to record the speeches and document the proceedings. Most onlookers were jubilant about this historic milestone. As one local newspaper proclaimed, "the day was evidently a railroad day and Henry Villard was king."[64] Although the main pageantry was now complete, Villard's excursion continued west to Portland, Oregon, before returning back east again.

While most of Villard's guests reported having had a memorable time and praised Villard for his generous hospitality, few stepped forward to provide him with the financial resources that he desperately needed. The publicity that the trip generated was indeed significant and international in scope, yet the company was deeply in debt and its stock had recently been hammered. Concerned that the railroad's future profits were limited, excursionists were reported to be wiring orders to sell the Northern Pacific stock they owned before the trip was even over.[65] Exhausted and near bankruptcy, Villard resigned as president four months later. He would return to the company's board of directors in 1888 and would be honored in later years for his achievements. But by the end of 1883, he was a broken man.

By comparison, Rufus Hatch fared even worse. The Yellowstone National Park Improvement Company's precarious situation was well known to company officials in the months leading up to the National Hotel's opening. Yet, though the hotel was well booked in August, evidence of the company's financial woes began to surface publicly by the summer's end. Badly in debt and unable to pay the laborers who had built the hotel, Hatch directed his anger towards Superintendent Conger and other government representatives. He was also mad because competitors had begun to make inroads in businesses that he believed he controlled. When he was asked to pay "an enormous price for lodging and breakfasting" at the "only hotel in the Park not belonging to the Company," he lashed out at the owner, according to a local newspaper, and threatened to "put up a tent hotel nearby that will cut off all the travel from his rival

and bust him up in business."[66] In the meantime, complaints from visitors about the National Hotel, especially its high rates, continued to annoy him.

Like Villard, Hatch received much positive publicity from those who joined his cross-country excursion. Again, though, few were inclined to invest in the Improvement Company. When the National Hotel closed for the season in early October, Hatch's future in Yellowstone was largely over. He, too, had lost big with the collapse of Northern Pacific's stock. At a time when the company continued to be the primary target of those who opposed private development in the park, it was becoming increasingly clear that it was on the brink of insolvency. That fall the company found itself without the resources to meet its payroll. Facing a long winter without money to support themselves, forty carpenters took control of the National Hotel and refused to work until their back wages were paid. In December Ashley W. Cole, an on-site company official, described the tense situation in a letter to Carroll T. Hobart: "We cannot hold out much longer . . . the Hotel is in the danger of being burned and the cattle being driven off."[67] The standoff continued through the winter with tensions only growing. By February Hobart reported to his brother, "Nothing short of the military will ever get possession of the Hotel. Men have got guns and propose to fight to the end."[68] By the following month Hatch was forced to declare bankruptcy, and the National Hotel was placed in the hands of a receiver, who paid the back wages and allowed the hotel to open for the 1884 season.

Among those who had long opposed the Improvement Company, few tears were shed about its fate. George Bird Grinnell was one of the first to crow about the company's demise in the pages of *Forest and Stream*:

The Improvement Company has been from the first a terrible bugbear—the ogre which threatened, at one gulp, to swallow our National pleasure ground. But for the prompt and energetic action of Senator Vest, it might well have irretrievably damaged this beautiful spot. . . . Like the bad giants of our childhood's stories, it is at last defeated and

crushed. From this danger, which was the most imminent of those that threatened, the Park has been saved.[69]

Financially ruined, Hatch was forced to sell his seat on the New York Stock Exchange and was never again the kingpin of Wall Street that he had once been. In 1885, Hatch would reminisce to a newspaper reporter about the extravagant party he had organized to Yellowstone: "I didn't ask the boys to spend a penny, and you can gamble that none of 'em pressed me to allow them to. Besides, while I was gone, I got on the wrong side of the market, and went hopelessly lame before I got back. I lost $460,000 dollars on that trip."[70]

Villard and Hatch were not the only men to lose their jobs in the aftermath of the 1883 season. Although Yellowstone superintendent Conger was receptive to the type of reform that Sheridan and Vest advocated, he failed to win support for his leadership and over time became regarded as the epitome of government inefficiency. In the wake of allegations about the park's mismanagement, the Interior Department hired W. Scott Smith, an official at the General Land Office, to investigate these reports. Traveling surreptitiously through the park in August, Smith heard many complaints from visitors and observed transgressions that were supposed to have been addressed following the passage of new park rules and increased funding from Congress. In October Smith filed a largely negative report with Secretary Teller. While he acknowledged that the Improvement Company was regularly undermining Conger's authority, he concluded that the superintendent "has either failed to comprehend the importance of the duties of his office . . . or has intentionally disregarded the same."[71] Vandalism and poaching continued unchecked, and the assistants that Conger had hired were characterized as incompetent at best.

When news of Smith's report became more widely known, Conger found himself battling with Smith, Hobart, and Secretary Teller. In a letter to Teller on November 6, he blamed the Improvement Company for his woes: "They help themselves indiscriminately to whatever they may want inside and outside of the Government inclosures without reference to any other interest

than their own."[72] Yet, support for Conger was fast evaporating. In December Grinnell came out against Conger in *Forest and Stream* and advocated that the military should take control of Yellowstone, since it was clear to many that the superintendent lacked the means to enforce his orders. As Grinnell later editorialized, "the Government is now the laughing stock of the Improvement Company and the skin-hunters and trespassers."[73] As it had during the previous year, Congress again became embroiled in a debate about Yellowstone. By March a new Yellowstone Park bill was enacted that voided all private contracts that had previously been negotiated. Furthermore, to protect the park, it allowed the Interior Department to request soldiers from the War Department—a measure that General Sheridan had long supported and that would eventually lead to the War Department's takeover of the park in 1886. Although Conger held onto his job for the moment, by September he would be replaced.

As in the past, President Arthur seems not to have participated, at least publicly, in this debate over the park. Instead, Senator Vest again took the lead in defending Yellowstone from private interests. In the president's annual message, which was read before Congress three months after his return, Arthur made no mention of the park. He did advocate, though, for the conservation of forests—an issue that he likely grew more aware of following his time in the West. Apart from this broad topic, however, Arthur did not initiate any measures, as park advocates had hoped, nor did he join any proceedings regarding Yellowstone's future. No reference to the park exists in his papers from this period.

This apparent lack of concern for Yellowstone should not be understood necessarily as disinterest, especially for a president who preferred a less visible role than many of his predecessors. Nor should it suggest that he rued his decision to travel there. From written accounts of the trip by others, it is clear that Arthur enjoyed his time in the West. Most often these writers foreground the president's passion for fishing. Several weeks after Arthur's return to Washington, a newspaper in Butte, Montana Territory, wrote that "the President does not hesitate to declare when describing

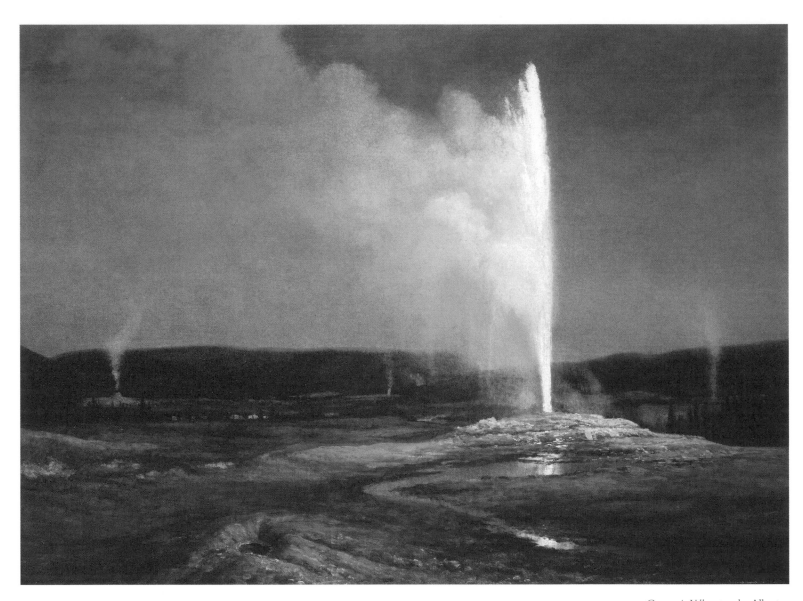

Geysers in Yellowstone by Albert Bierstadt, oil on canvas, c. 1881. Buffalo Bill Historical Center, Cody, Wyoming, U.S.A.; Gift of Townsend B. Martin, 4.77

his angling exploits in the National Park that it contains the finest fishing grounds in the world."[74] In November, Senator Vest wrote an extended article about their Yellowstone journey for *Forest and Stream*. Joking that "the President's array of tackle was enough to bewilder an entire fishing club," Vest described how fishing in the West required a certain expertise and stealth. After a slow start, the party eventually mastered the art, with Arthur leading the way. He described one afternoon on the Snake River where the president caught 110 pounds of trout. Vest also reported, "I saw the President take three white trout at one cast, weighing together seven pounds, and it is hardly necessary to say that with a six-ounce rod it required both skill and patience to accomplish the feat."[75]

Arthur's fondness for the West was also evident back in Washington. That fall, the president oversaw the refurbishment of the White House. Particular attention was paid to redecorating his private rooms. There, among other changes, he decided to exhibit several Western landscapes by artist Albert Bierstadt, a friend since his days in New York. As one newspaper described, "Several of the best works of Bierstadt, loaned by the artist, adorn the walls, a large painting of the Yellowstone region being the most striking." This painting was most likely *Geysers in Yellowstone,* a work Bierstadt completed following his own trip to the park in 1881. In addition to Bierstadt's paintings, one of the private bedrooms held "two long cases marked 'C. A. A.' containing the fishing tackle belonging to the president."[76] As a young man, before the Civil War, Arthur had traveled with a friend from his home in New York to Kansas. He contemplated settling in the West, but eventually returned back east after several months, upon learning of the sudden death of his fiancée's father. In these new rooms in the White House, the president surrounded himself with reminders of both his youth and his recent trip.

Haynes's album served a similar function. The idea to commemorate this journey with a private volume of photographs appears to have been Robert Lincoln's. On October 20, General Sheridan wrote Lincoln and enclosed six copies of his brother's recent dispatches "for you to use in connection with the

photographs if it is still your determination to have them printed in book form."[77] That fall Sheridan was transitioning into a new and prestigious appointment. With William T. Sherman stepping down as commanding general of the U.S. Army, Arthur and Lincoln had chosen Sheridan to replace him. Rather than submitting a report of the expedition as he had done during the two previous summers, Sheridan sent his brother's dispatches instead. He seems not to have wanted or had time to complete a separate report—an indication that the presidential trip to Yellowstone was more recreational than the military expeditions he had led in the past.

Lincoln's desire to create a photographic album of Arthur's journey reflected a burgeoning interest during this period in using photographs to capture the images of noteworthy people and places. The urge to collect photographs—often in specially designed albums—as memorable keepsakes became a popular pursuit in the United States beginning in the 1860s. Similarly, though for different purposes, government officials and private entrepreneurs began to hire photographers to create images to accompany reports about significant projects. As secretary of war, Lincoln would have known of the photographic albums that the War Department had commissioned in the recent past, including those associated with surveying expeditions in the West. While none of these previous efforts had featured a president, the photographic album of Arthur's Yellowstone trip was inspired by such volumes and the broader phenomenon of personal albums. Photographers like Haynes recognized that such albums represented a new market for their work, and they seized the opportunity to create images that satisfied this demand.

Back home again in Fargo, Haynes and his studio assistants were busy that fall printing material from the past summer. A local newspaper characterized the buzz of activity thus: "For the past few weeks [Haynes's] studio has been kept very busy getting off the views of the 'spike driving' excursion, and those taken while Mr. Haynes was with President Arthur upon his trip from the Union Pacific to the Northern Pacific, through the National park, and other picturesque localities of the eastern slope of the Rocky mountains." Haynes had orders from members of both the Arthur

and Villard parties to fulfill, and new requests were arriving daily from individuals throughout the United States. As the reporter noted, "he received last night an order from New York for twenty-five gross of stereoscopic views, and nearly every day the mail brings similar requests."[78] According to his catalogue from the period, Haynes sold stereographs for two dollars per dozen or fifteen dollars per gross. He sold his large-format "Imperial" views for fifty cents each or five dollars per dozen.[79] Overall, his work from this summer proved to be quite lucrative. Optimistic about the future given this success, Haynes began making plans to enlarge his studio in Fargo and once again inquired about an official lease from the Interior Department to build a photographic studio in the park.

The leather-bound album of photographs from the presidential excursion was not completed until the following spring. In the meantime, he printed a small selection of views and sent these photographs to various participants. Haynes mailed the president his prints in late January. While Arthur didn't write Haynes personally to thank him, his private secretary Frederick J. Phillips did. In his note on White House stationary, Phillips wrote that the president "is very glad to have these photographs which he considers very good, and desires me to thank you for your courtesy in sending them."[80] Haynes received other thank-you letters, including a personal note from Secretary Lincoln, who exclaimed, "I must say that I never saw such fine photographs, and they are all the more remarkable in being taken under the difficulties which you must have encountered. They will always make for me a most interesting reminiscence of our journey."[81]

While such letters were obviously a source of pride to Haynes, the photographer hoped that his contribution to the president's trip might help him secure a lease from the Interior Department, which continued to delay in ruling on such applications. Growing impatient, Haynes decided in March to travel from Fargo to Washington, where he aimed to meet with government officials and other legislators. After arriving in the capital, he began by reaching out to Dakota Territorial Senator John B. Raymond, who promptly pledged his support. Together, the two men visited the Interior

Department and met with Assistant Secretary Merritt L. Joslyn. In a long letter to Lily, Haynes described what happened next:

> We made our wants known and [Joslyn] said there was no law to lease anything but for hotels. I told him I did not want to start a hotel only a studio. So the matter looked blue. Joslyn said the bill regarding leases had passed the Senate Saturday and would be up before the House of Representatives Tuesday and if I should see Senator Vest immediately I might get him to amend the bill granting me a lease. Raymond and I started immediately to the Capitol and went to the Senate chamber. I sent my card in to Senator Vest and he came out. [Vest] was very much pleased to see me. I told him how I was fixed and what I wanted. He said, "well my boy I'll fix that and when I present the bill it will have an amendment to grant you the lease." We had a pleasant chat and I felt as if I was accomplishing something.[82]

After seeing Vest, they next met with U.S. Senator Omar D. Conger of Michigan, the older brother of the Yellowstone superintendent. Haynes had met Senator Conger the previous summer while covering the Villard excursion. As Haynes reported to Lily, "The first thing he said, 'Can I be of any help to you,' I told him my mission [and] he said we will see you through and he invited me up to his house to dinner which I accepted for tomorrow. I was introduced to Senator [John A.] Logan, Sen [Dwight M.] Sabin. [I] called on Sec of War Lincoln, who was also glad to see me." While in Washington, Haynes was also working to complete his leather-bound album of photographs. In particular, he went to see the book's printer to finalize arrangements for its publication. He also hoped to call on President Arthur, though it's unclear whether that meeting ever occurred. Feeling confident that his lease application would be accepted, he remarked in closing to Lily:

> I never could have got my lease by writing as I find it takes personal hand work to get anything done. I feel quite hopeful and have met with no opposition. If the Park Improvement Co knew I was here they would try to prevent it. The whole

Haynes's Photographic Studio at Mammoth Hot Springs by Frank Jay Haynes, albumen silver print, c. 1885. Burlingame Special Collections, Montana State University–Bozeman Libraries

matter rests with Sen Vest who is my friend and never would have been had I not met him on the Pres trip and sent him a series of views. The views are complimented in every land. The Pres, Lincoln, and Gen Sheridan think they're fine. Splendid sunshine weather here. Need no overcoat. Very warm. Will start for home in a day or two and I think you will not be sorry I came. Yours with love.[83]

On March 20, 1884, the Interior Department approved Haynes's first Yellowstone lease. At the cost of two dollars per acre annually, he would be permitted to build a studio on eight acres in the Upper Geyser Basin. Yet, the entrepreneurial Haynes was still not satisfied. Desirous of a presence at Mammoth Hot Springs, he asked Joslyn not long thereafter whether he might modify this lease in order that he might also operate a studio there. Joslyn agreed, and in October—two weeks after the birth of Haynes's son Jack Ellis Haynes—the lease was restructured into two four-acre parcels. By

the following summer Haynes had successfully opened both studios and had inaugurated his railcar photographic studio, Haynes Palace Studio, which traveled to communities throughout the Northwest on the lines of the Northern Pacific. Through these moves, Haynes had positioned himself as one of the leading photographers in the West and the premier photographer of Yellowstone, a position that he maintained throughout his life and after.

While President Arthur returned to his duties in Washington that fall riding a wave of good press and seemingly in better health, he continued to suffer periods of fatigue and illness. His disease did not prohibit him from his work, nor did it keep him from continuing to embark on fishing trips. Only two weeks after arriving back in Washington, he set off for the resort town of Newport, Rhode Island, to see his sister, daughter, and others. While there, he went fishing and caught a record-setting eighty-pound bass. He also spent time that fall contemplating a run for the

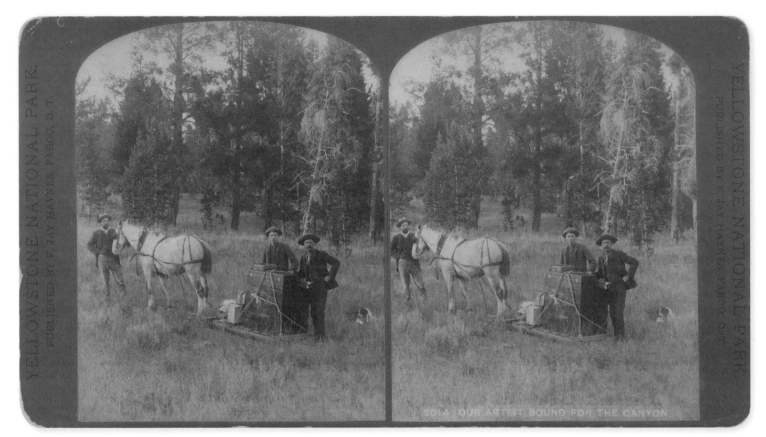

Our Artist Bound for the Canyon by Frank Jay Haynes, albumen silver print, 1887. National Portrait Gallery, Smithsonian Institution; gift of Larry J. West

White House. Yet, it is clear that his health was far from perfect. Newspapers published occasional reports about recent bouts of sickness that forced him to retire to his bed. As a Montana paper wrote not long after the New Year, "President Arthur's health is said to be failing under the severe burdens of his executive duties. . . . Notwithstanding his trip to Florida and Yellowstone Park during the summer his physical strength has steadily failed. The former trip resulted only in sickness and fatigue while the latter was one trying upon his strength."[84]

Largely because of his declining health, Arthur held back from actively seeking the presidential nomination at the Republican convention in early June. He may have wished that his supporters might have fought harder to secure his nomination, but he lacked the energy to campaign for it. Several men threw their hat into the contest, including Secretary Lincoln, who received the endorsement of the *New York Times*. At the Chicago convention, though, James Blaine was chosen as the Republican nominee with Senator Logan as his running mate. Perhaps to relieve their disappointment, Arthur

and Lincoln traveled together the following week to Long Island, New York, for several days of fishing. The two men clearly enjoyed each other's company, and such an excursion helped them to put the recent political developments behind them.[85] In August, Arthur also went fishing in the Catskills, a trip that he had made in summers past with Senator Vest. Despite Vest's absence on this occasion, he reported having had a good time, though he indicated that there was "no comparison" between the Catskills and Yellowstone. At least one paper suggested that Vest, a Democrat who was seeking reelection in the fall, likely "thought it would hurt his chances to be in cahoot with a Stalwart Republican President."[86]

At the polls in November 1884, Grover Cleveland, the Democratic governor of New York, prevailed in a close contest against Blaine for the White House. During that fall, Arthur did little to support Blaine, who afterwards was upset at Arthur for his failure to deliver New York for him. However, Arthur was not well and had little motivation to campaign for Blaine. Following Cleveland's inauguration, Arthur left office quietly and returned to his law practice. Although some supporters later encouraged him to run for the Senate, he declined their invitation. Increasingly weakened by disease, Arthur passed away on November 18, 1886, at the age of fifty-seven. The day before his death, Arthur burned most of his private papers, likely in an effort to obscure the record of his earlier role in the Stalwart political machine. Fortunately, the album of photographs from his Yellowstone trip was spared destruction. Despite his infamous past, most felt a fondness for the former

president. As the publisher Alexander K. McClure wrote after his death, "no man ever entered the Presidency so profoundly and widely distrusted as Chester Alan Arthur, and no one ever retired from the highest civil trust of the world more generally respected, alike by political friend and foe."[87]

Much had changed in the park in the short period after the president's visit. While many understood his trip to be largely recreational, it brought into focus a series of pressing issues, which Congress and others addressed during this period—albeit often incompletely. By the time of Arthur's death, Congress had called on the War Department to run the park. A new superintendent was now in place. Furthermore, a syndicate from St. Louis now owned the National Hotel, and visitation had continued to grow. The summer of 1883 proved to be a watershed moment in Yellowstone's history. After eleven years of neglect and uncertainty, the modern park was born. Three weeks before Arthur's death, *Forest and Stream* published a traveler's account of a visit to Yellowstone. Like so many descriptions of the park, it spoke in glowing terms about Yellowstone and the enjoyment experienced there. The account also mentioned that a photograph of the fish that President Arthur and Senator Vest had caught now hung in the lobby of the National Hotel. Although the party inquired about who caught more, no one would tell them. Perhaps no one knew, or perhaps no one was willing to let the secret out.[88] Whatever the case, President Arthur's trip was now part of the storied mythology of Yellowstone. Haynes's photographic album provides a unique window into that past.

JOURNEY THROUGH THE
YELLOWSTONE NATIONAL PARK
AND
NORTHWESTERN WYOMING,
1883.

ALBUM NOTES

———◆———

The following reproductions of Frank Jay Haynes's photographs were made from the album owned by the Library of Congress, Prints & Photographs Division, Washington, D.C. This album was originally owned by President Chester A. Arthur. Colorado banker Victor Assaiante acquired it in 1945 from the widow of Chester A. Arthur, III, and in 1969 deposited it and other Arthur papers at the Library of Congress. While Jack Haynes claimed that his father originally created twelve copies of the album—one for each of the principal participants named on the album's title page—only six are known to exist in institutional collections. The five other copies are located at the Yale Collection of Western Americana, Beinecke Rare Book and Manuscript Library (George G. Vest's copy); the Abraham Lincoln Presidential Library in Springfield, Illinois (Robert T. Lincoln's copy); the DeGolyer Library, Southern Methodist University (Michael V. Sheridan's copy); the Western Americana Collection, Princeton University (unidentified owner); and the Yellowstone National Park Heritage and Research Library (unidentified owner). The six known copies have the same leather binding, the same title page, and the photographs and captions are identical, though in a few cases certain images appear in a slightly different sequence.

The album contains 104 photographs, all by Frank Jay Haynes. Following the album's title page, there are thirty-two pages, each featuring a single large-format photograph. Although the dimensions vary slightly, each of these images measures 6 × 8¾ inches. After the thirty-two large-format images, there are twelve additional pages, each containing six small-format photographs. Each of these images measures 3¾ × 2⅞ inches. Prior to printing

his photographs, Haynes imprinted a specific title and a catalogue number at the bottom of each negative. This information appears on most of the prints, and for this volume we have reprinted this information alongside each photograph. In addition to Haynes's photographs, the original album also contains the Associated Press dispatches written during the trip by Michael Sheridan. Printed on forty-three separate sheets, these are interspersed throughout the forty-four pages of photographs. Sheridan's dispatches were a summary record of each day's activities. While they accompany Haynes's photographs, they were not intended to serve as captions to these images. Likewise, Haynes created his photographs independent of Sheridan's reports.

Haynes used two cameras throughout the trip: a large-format camera that created eight-by-ten-inch "Imperial" negatives and a smaller stereograph camera. In the original album the large-format photographs are all grouped together at the front and are followed by the smaller photographs at the back. Within the two groupings, the photographs are sequenced chronologically. For this volume we have eliminated the two separate groupings and joined large images together with small images to present views of the expedition in a chronological fashion. This arrangement foregrounds the narrative sequence of the trip for readers and juxtaposes more directly the large and small photographs that Haynes completed. Thirty-five of the original 104 photographs from the main section are reproduced in an appendix, because we determined that these photographs were most often variants of other photographs in the album. Apart from these changes, this volume presents Haynes's photographs and Sheridan's dispatches in a fashion consistent with the original album.

JOURNEY

THROUGH THE

YELLOWSTONE NATIONAL PARK

AND

NORTHWESTERN WYOMING.

1883.

———— •• ————

PHOTOGRAPHS

OF

PARTY AND SCENERY ALONG THE ROUTE TRAVELED,

AND

COPIES OF THE ASSOCIATED PRESS DISPATCHES SENT WHILST EN ROUTE.

———— •• ————

THE PARTY:

CHESTER A. ARTHUR, President of the United States.
ROBERT T. LINCOLN, Secretary of War.
PHILIP H. SHERIDAN, Lieutenant General.
GEORGE G. VEST, United States Senator.
DAN. G. ROLLINS, Surrogate of New York.
ANSON STAGER, Brigadier General, United States Volunteers.
JNO. SCHUYLER CROSBY, Governor of Montana.
M. V. SHERIDAN, Lieutenant Colonel and Military Secretary.
JAMES F. GREGORY, Lieutenant Colonel and Aide-de-Camp.
W. P. CLARK, Captain, Second Cavalry, Acting Aide-de-Camp.
W. H. FORWOOD, Surgeon, United States Army.
GEO. G. VEST, JR., Saint Louis, Missouri.

ESCORT:

TROOP G, FIFTH CAVALRY, Captain E. M. HAYES, Lieutenant H. DEH. WAITE.

FORT WASHAKIE, WYOMING (1554)

GREEN RIVER, WYO., *Aug. 5—*

On the arrival of the Presidential train at Cheyenne at 9 o'clock last night a large number of people were at the station, and during the short time we stopped there the President, Secretary Lincoln, and Senator Vest made a few remarks and were introduced to the officials of the Territory. At 9:30 the train moved out from the station under the charge of General Superintendent Dickinson, of the Union Pacific Road.[1] Eighteen miles west of Cheyenne we passed over the summit of the Black Hills of Wyoming, the highest point on the Union Pacific Road, and where has recently been finished a monument to Oakes Ames, one of the original projectors of the road.[2] The train arrived at Green River, Wyo., at 10:30 to-day (Sunday), and in consequence of the pre-arranged plan to spend Sunday at this point, we remained quietly on the train all day.

To-morrow morning at 7 o'clock we take the spring wagons for Washakie, and will encamp to-morrow night on the Sweetwater, one hundred and one miles north of this point. The next day we will drive into Fort Washakie, fifty-fives miles. There are three of these spring wagons. The President, Secretary Lincoln, and Gen. Sheridan will ride in No. 1; Senator Vest, Judge Rollins, and Gen. Stager in No.2; Gov. Crosby, Mr. George Vest, Surgeon Forwood, and your representative in No. 3. We expect to make about ten miles an hour over a fine natural road, and to reach Washakie about 3 P.M. August 7. As there is no telegraph station this side of Washakie, you will not hear again from me till after that point.

POST TRADER'S STORE, FT. WASHAKIE (1555)

FORT WASHAKIE, WYO., *Aug 7.—*

The President and party left Green River Station on the Union Pacific Railroad, at 7 o'clock the morning of the 6th, having spent Sunday at that place. The three spring wagons in which the party were seated were drawn by four fine mules to each vehicle, and the first day's drive was made by relays which had previously been placed twenty miles apart; one hundred and one miles had been covered, and the evening shadows had only commenced to settle behind some of the highest hills when we arrived at the Sweetwater, a beautiful mountain stream upon the banks of which Captain Lord, Depot Quartermaster at Cheyenne, had, by direction of Gen. Sheridan, pitched tents for our use, and accumulated all the conveniences necessary for our comfort, even to a most elaborate dinner.[3] As a compliment to the Captain for the perfection of the arrangements, this camp was named "Camp Lord." The President enjoyed the ride greatly, being seated on the outside of the wagon with the driver during the last forty-five miles. The road leads over a country much of which is covered with sage brush and sand, but there are also some smiling valleys, rolling prairies and rugged bluffs, and the gravelly loam of the soil, for a portion of the distance, makes a splendid natural road, use only being necessary to perfect it.

The grey, dreary desolate sage brush region, and places where the sand had been drifted by the winds into little piles behind every bush and stone by which we passed, at first glance would seem to be absolutely worthless, but here in winter herds of cattle and flocks of sheep crop the white sage and long spears of grass and thrive wonderfully well without other food. At this season, except for some few of the better ranges, the antelope, jack rabbit and sage hens have undisputed possession.

At 7 o'clock a.m. of the 7th, after a bountiful breakfast, the party left Camp Lord for Fort Washakie, distant fifty-five miles. Only one relay of mules had been pre-arranged and these had been placed at Little Po-po-Agie, thirty-one miles away. Nine miles out from camp we came upon South Pass City, on the banks of a small tributary of the Sweetwater, walled in by granite hills, but deserted and desolate.[4] Two or three of the buildings were occupied, the rest were fast falling into decay. Four miles over a mountain road brought us to Atlantic City, also nearly deserted, a stage station, post-office and saloon sole relics of the activity and prosperity which a few years since thrived and pulsated with all the vigor which bad whiskey and rich anticipation could give the reckless inhabitants of a new mining camp.[5]

1556. WASHAKIE HOT SPRINGS NEAR FT. WASHAKIE.

SHOSHONE CHIEFS, FT. WASHAKIE (1557)

Each of these camps should have been proud at any time to have been called a village, and now in their decay and desertion seem only physical representatives of broken hopes and ruined lives. Near by as we rode along we could see that a little work was still being done at some of the mines, but this seemed mostly the effort and tenacity of despair. We passed old Fort Stambaugh, abandoned, sold, and metamorphosed into a quiet sheep ranch, and rising to the crest of quite a high mountain we found, five miles from Atlantic City, a small collection of huts, hovels and frame buildings called Miner's Delight.[6] There some little life and activity still existed, but the name seemed the acme of irony and sarcasm. Both placer and quartz mining are carried on. The party stopped and some miners brought to the President a "pan" of "pay dirt" and went through the process of washing out the gold and a few glittering grains resulted. Passing down the steep slope of the divide and through the Red canon, walls of argillaceous sand stone, colored deep red with hematite, we reached the Little Po-po-Agie and stopped an hour for luncheon.[7] Following down this stream some little distance, then crossing a small divide, we came upon the Big Po-po-Agie and the town of Lander.[8]

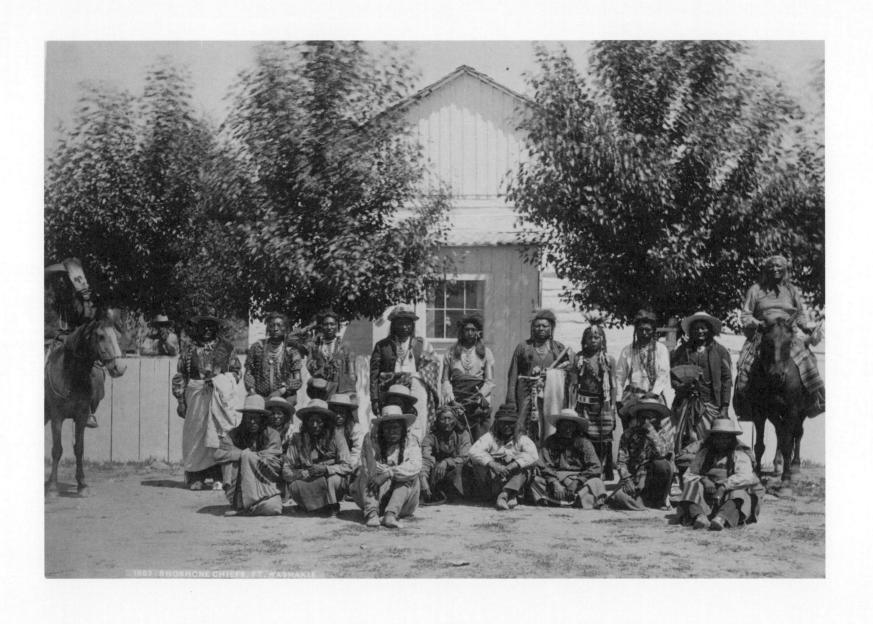

1557 SHOSHONE CHIEFS, FT. WASHAKIE.

ARAPAHOE CHIEFS, FT. WASHAKIE (1558)

Thrift and industry had turned the waters of the river upon the lands of the valley, and the magical touch had brought prosperity to the little community, and given the inhabitants Homes in striking contrast to the mining camps we had passed. Here women were to be seen and little children were running about. The valley seemed smiling and happy, while in the mining camps only men herded together and now only the ashes of their fierce dissipation and blasted expectation remain.

From the crest of a hill nine miles from Lander, we looked down upon the white tents, pitched in the valley near the "Hot Spring," which were awaiting our arrival and which will be our shelter until we reach the railway beyond the distant Yellowstone Park. As we drove across the plain, some three miles in extent, the Shoshone and Arapahoe Indians, upon whose reservation we now are, turned out in large numbers to welcome the Great Father, and dashed around the President's party most gaudily and fantastically arrayed, displaying their skill in horsemanship and gratifying their curiosity.[9]

The party will rest here to-morrow and then mount their horses and take the trail for the Yellowstone National Park.

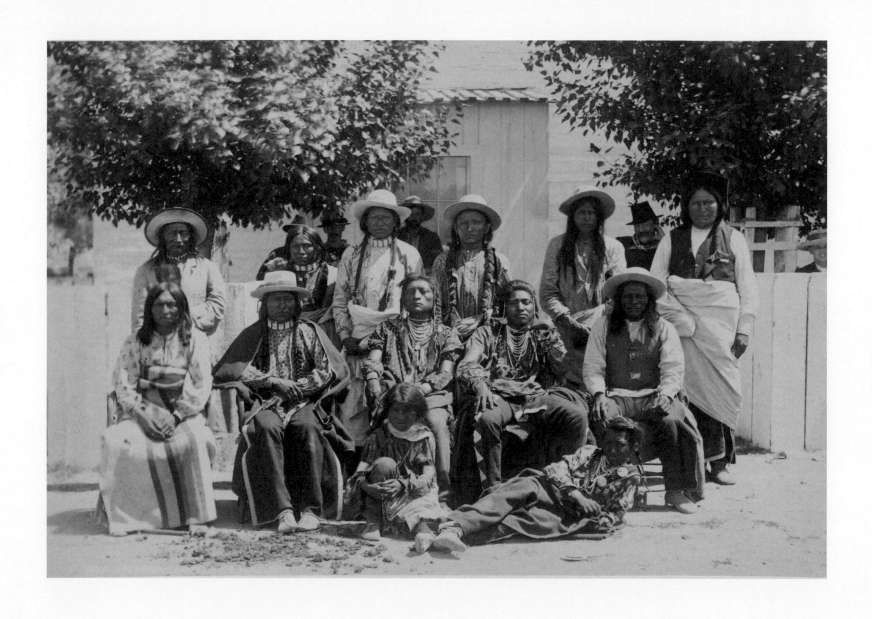

PRESIDENTIAL AMBULANCE TRAIN, FT. WASHAKIE (1559)

FORT WASHAKIE, WYO., *Aug 8.—*

The Presidential party has spent the day here at Fort Washakie, preparatory to setting out on their ride to the Yellowstone in the morning.

In accordance with the expressed wish of the Shoshone and Arapahoe Chiefs their people were afforded an opportunity of calling upon the President at 3 o'clock this afternoon. Shortly before that hour they gathered on the plains to the number of about 500 warriors, and, mounted upon their handsome ponies, dashed forward in line for about 1,000 yards to a point near which the President stood awaiting them. The column then halted, and several chiefs dismounted and approached him. Among them were Washakie, Chief of the Shoshones, from whom this post takes its name, and Black Coal, Chief of the Arapahoes, a tribe which, within a few years, has been permitted to share the occupancy of this reservation.[10]

The President thanked his visitors for calling upon him; congratulated them upon their fine appearance; assured them of his interest in their welfare and of the satisfaction with which he had heard of their exemplary conduct and growing attention to the practice of industrial pursuits.

His address, which was admirably suited to the occasion, was interpreted to the Shoshones by an English-speaking member of the tribe, who bears the name of Norcutt, and to the Arapahoes by one of their number, who has been educated at the Carlisle School, in Pennsylvania.[11]

The Chiefs repeated to their respective tribes what had been said to them by their Great Father, and the announcement was received with demonstrations of applause.

Both Washakie and Black Coal made pertinent replies. They thanked the President for honoring them with a visit; avowed their purpose of living at peace with the whites, and adopting as fully and as rapidly as possible their customs and manners of life. These addresses, as interpreted, were full of expressive metaphors, and were at times positively eloquent. The Arapahoe interpreter found no little difficulty in making himself understood. His efforts were ably seconded by Capt. Clark, of Gen. Sheridan's staff, who has thoroughly mastered the beautiful and expressive sign language, which affords a medium of communication for the two tribes in their intercourse and also with the whites, and which fully supplies the place of vocal speech.[12]

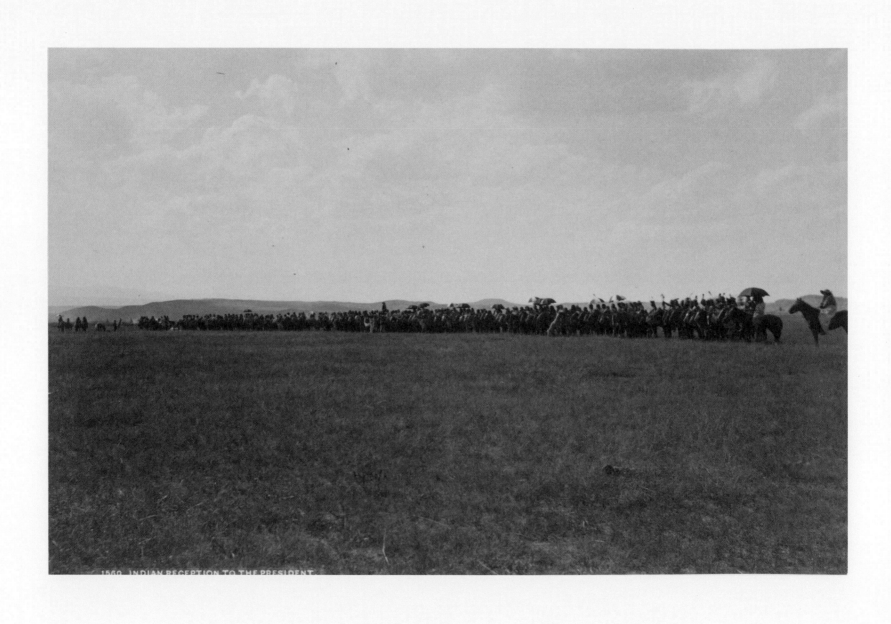

1569. INDIAN RECEPTION TO THE PRESIDENT.

CHIEF SHARP NOSE AND FAMILY (1748)
INDIAN RECEPTION TO THE PRESIDENT (1743)
INDIAN DANCE—PRESIDENT'S RECEPTION (1742)

After the addresses were concluded Sharp Nose brought forward an Indian pony and placing the lariat in the hands of the President presented the handsome animal for the use of his daughter.[13] Gifts of moccasins and leggings were also made to the members of the President's party. Then followed a war-dance, in which twenty young Shoshone braves took part; eight beating the drum and chanting a weird song for exciting the efforts of their fellows. Some of the dancers were nearly naked, their skin being painted in various colors; others were gayly dressed in flashy-colored costumes, no two of which were alike. Some were adorned with beads, feathers, and every sort of Indian ornamentation. The dance afforded much entertainment to the Presidential party.

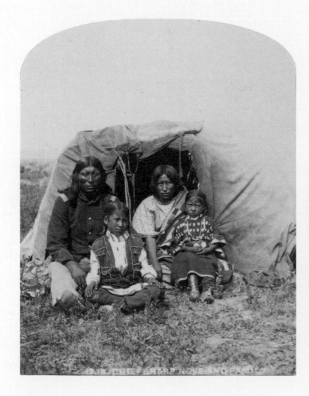

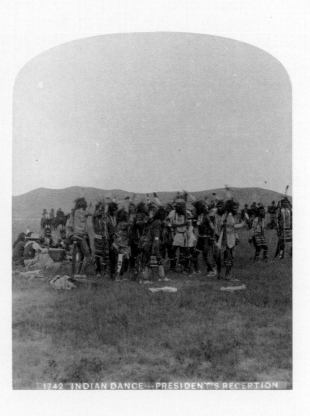

INDIAN RECEPTION TO THE PRESIDENT (1740)
INDIAN RECEPTION TO PRESIDENT ARTHUR (1744)
INDIAN RECEPTION TO PRESIDENT ARTHUR (1746)

CAMP ROLLINS, WYO., *via* FORT WASHAKIE, WYO. TER., *Aug. 9.—*

After the Indian dance yesterday at our camp, near Fort Washakie, Captain Hayes, commanding Troop G, Fifth Cavalry, gave the President an exhibition drill, the commands being given by trumpets.[14] The drill included ordinary manoeuvres [*sic*] by troop formation, skirmishing both on horseback and on foot, and ended with a charge. Just after this about 250 mounted Indians, Shoshones and Arapahoes, gave a sham battle exhibition, with the manoeuvres [*sic*] executed by them in actual warfare. Their horsemanship was surprising, nearly every one riding bareback, and many without bridles.

Senator Vest, member of the Senate Committee, had an interview with Washakie, Chief of the Shoshones, and Black Coal, of the Arapahoes, about 5 o'clock, there being present a large body of Indians from both tribes. The Senator's inquiries were directed principally as to whether the Indians would accept tenure in severalty instead of tenure in common, as now held by them. The Senator urged them to take their lands, 160 acres to each head of a family and eighty acres to unmarried Indians.

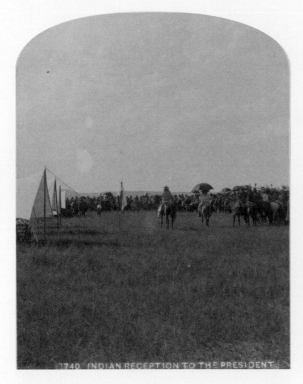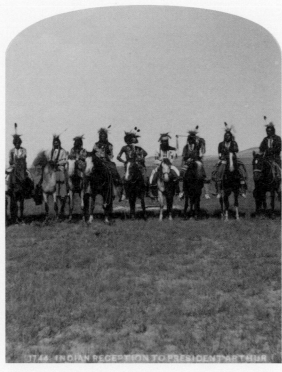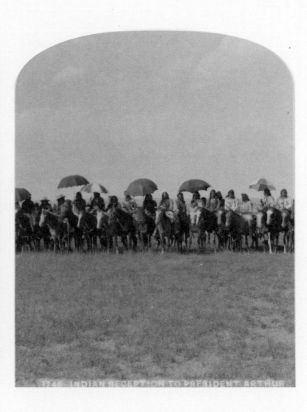

PRESIDENTIAL ESCORT, FT. WASHAKIE (1561)

They have 2,800,000 acres in this reservation and about 1,900 Indians, both tribes included, and under the tenure in severalty would get $250,000 interest annually upon the bonds for these lands if sold to the Government. All the Chiefs expressed themselves against tenure in severalty.[15] They were very anxious to have permission to trade with the post trader at the fort, which is the only other store on the reservation allowed besides the Indian trading store, stating they could only receive $7 for the buffalo robe at the agency store, whereas at the military store they were offered $10.

At 7 o'clock sharp this morning the President and party broke camp and started on horseback, with the escort and pack-mules following, crossing Little Wind River near Fort Washakie, then passing over a rough and broken country, with no water a distance of nine miles, stopping for a short time on the top of the divide, giving us a fine view of Crow Heart Butte and the Owl Creek, Wind River and Shoshone Mountains.

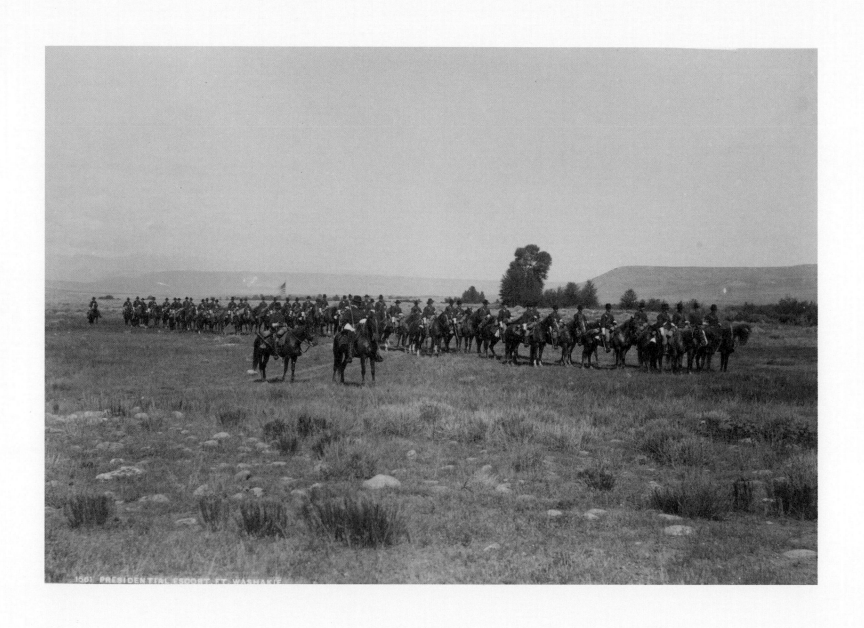

1001 PRESIDENTIAL ESCORT, FT. WASHAKIE

PRESIDENTIAL ESCORT, FT. WASHAKIE (1562)

From this point we passed over a very rocky country, climbing and descending alternately high and stony hills until we reached this camp, which is situated on Bull Lake, a fork of the Wind River, a distance from this morning's camp of twenty-one miles. The party is well and enjoyed the ride greatly. The President proves to be a good horseman and came into camp like an old campaigner. Immediately after our arrival at this place, which is near a beautiful trout stream, the President took his rod and soon landed the first trout, keeping up his old reputation of being a fine fisherman. He enjoys camp life very much, is up and out of his tent among the first at 5 o'clock each morning, and with flannel shirt and large hat roughs it with the rest. Surrogate Rollins having distinguished himself in horsemanship on this march of twenty-one miles, and in compliment to him, Gen. Sheridan named our first camp "Rollins," which honor was thoroughly approved of by the whole party.

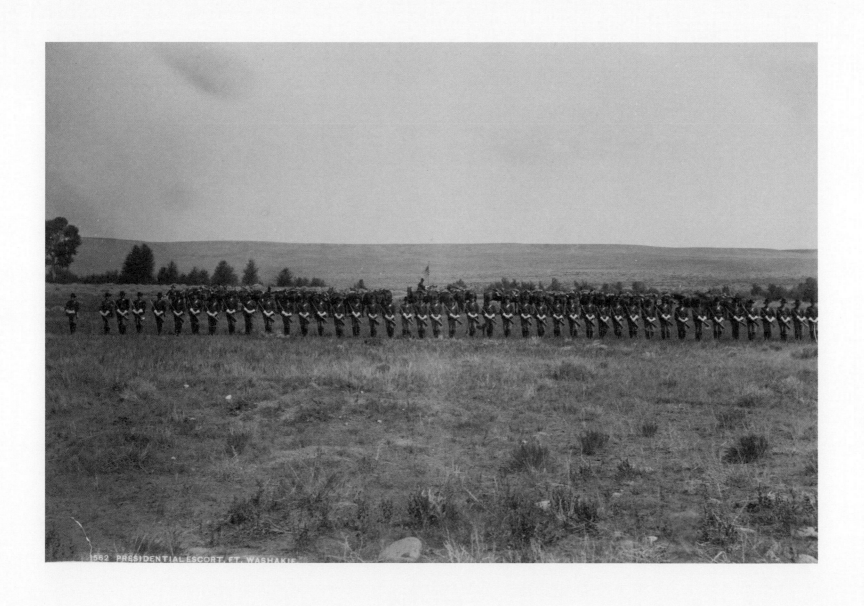

1552 PRESIDENTIAL ESCORT. FT. WASHAKIE.

WASHED BLUFFS, WIND RIVER VALLEY (1564)

CAMP VEST ON SPRING CREEK,
via FORT WASHAKIE, WYO. TER., *August* 10.—[Special]—

The day so far since leaving Camp Rollins, at Bull Lake Fork this morning at 7 o'clock, has been very uneventful. The President and all the members of the party are in excellent health and spirits. The country traveled over to-day has been mostly sagebrush and bunch grass mesas, varied by alternate ascents and descents of steep hills, covered with loose stones, which made precarious footing for the animals. We cannot help wondering why so much material was wasted in the making of so many apparently useless ridges when there are plenty of gulches that could so well be filled all along the route. However, the glorious Wind River and Owl Creek Mountains, with their snow-clad peaks, are in sight, and afford restfulness to the eyes of travelers who are pursuing their way across the dry and heated mesas below.

The Camp on Spring Creek, however, is a very delightful one, on pleasant ground, with plenty of the essential requirements of good camping-places—wood, water and grass. To the eastward of us is the Crow Heart Butte, which is a noted landmark of the Wind River Valley, and of it the photographer has obtained several pictures.[16]

This dispatch has to leave by couriers at 3 o'clock this afternoon, so no reports can be made to-day of the results obtained by the fisherman. The camp is named Camp Vest in honor of Senator G. G. Vest, who is one of the most enthusiastic and successful anglers of the party. After my dispatch of yesterday from Bull Lake Fork, both the President and Senator Vest brought into camp fine creels-full of trout as the result of their afternoon's sport.

There are no special or professional correspondents with the party, and all dispatches purporting to be from such persons are spurious.[17]

1564. WASHED BLUFFS, WIND RIVER VALLEY.

WASHED BLUFFS, WIND RIVER VALLEY (1565)

CAMP CROSBY ON DINWIDDIE CREEK, WYO., *Aug.* 11,
via FORT WASHAKIE, WYO., *Aug.* 12.—

Breaking camp at 6:30 A.M., a leaden gray sky and drifting clouds, added to the slight rain and heavy dew of last night, gave a delightful freshness and coolness to the air, as the party started on the day's march. The rest from the burdens of official and social life, the exhilarating effects of the climate, the wearing away of the little soreness that some of the party had felt from the riding—all the good effects, in fact, of this outdoor life were seen in the buoyant manner in which the members of the party mounted and rode away. Senator Vest again scored the greatest number of trout yesterday, but a shower in the afternoon quickly put an end to the sport and prevented very much competition. The route lay along an old Indian trail made dim and faint by time. A portion of the party left the column and skirted the foothills and mountains to the left in search of game and scenery, but the game had nearly vanished; it is well nigh exterminated; only one deer and one antelope were seen. As coming events are sometimes said to cast their shadows before, so this may perhaps indicate the sad fate of the Indian race.

1565 WASHED BLUFFS, WIND RIVER VALLEY

CROW HEART BUTTE, WIND RIVER VALLEY (1566)

A march of fourteen miles brought us to Dinwiddie Creek, a noisy mountain stream rushing down in a boisterous way to join its waters with Wind River. In honor of the Governor of Montana this camp has been named Camp Crosby. The country passed over to-day was mostly rolling, interspersed occasionally with valleys susceptible of irrigation, but the future prosperity of this section depends mainly on its being utilized for grazing purposes. The grass has already taken on a brownish tint, the first indication of the curing process of this climate, and in this lies the great secrets of its retention of nutritious properties.

It seems a pity that these streams should have lost their Indian names, like, for instance, the creek where we made our first camp. It is called by them Moaning or Crying Buffalo Creek, and here in the winter when there is ice on the lake a weird and pitiful sound is heard, much resembling the moan of a buffalo in distress. Again, at our present camp the Indians call the stream the creek with God's Bridge, and some ten miles above its mouth a natural bridge about 300 yards wide spans the chasm through which the waters rush. This bridge is scarred and marked by trails made by Indians and game, which are distinctly visible from the heights a mile above it.

CROSBY CANYON, LOOKING EAST (1568)

The canon is grand—so grand and beautiful in fact that one of the party who has wandered much in foreign lands says of it: "Nothing there can in any way compare with it." This gorge in the mountains carved by the Master's hand is hard to describe, but one cannot look at it without some awe of the Great Architect. Near the head of the stream it is crescent in shape, backed by mountains, far down whose sides lie great snow-banks which have rested there during all the eternity of the past. Then come the somber gray rocks, gloomy and barren, above all vegetation, and seeming to frown down upon the bright waters and green foliage below. The stream opens out at a short interval into lakes. Several of these are two miles in diameter, and have a pale green color.

The tents had been pitched but a few minutes and the fisherman had just commenced their efforts when from the northwest a great black cloud came sweeping over the bluffs, and a hail and rainstorm really made the party feel that they were enduring hardships, but they are just mild enough to be agreeable.

1568 CROSBY CANYON, LOOKING EAST.

CROSBY CANYON AND NATURAL BRIDGE (1569)

CAMP STAGER, ON TORRY'S LAKE, WYO. TER., *Aug.* 12.—

It was determined last night to move our camp this morning a few miles to a place where there would be more abundant grazing for the horses and mules. Accordingly at 6:30 A.M. every one was in the saddle and we started up the valley on the right bank of Wind River. Owing to the rain of yesterday the trail was in splendid condition for comfort in marching. The sun was obscured by clouds, and, with a temperature of below 50 degrees Fahrenheit all day, our short journey could not but be enjoyable. At the end of an hour's travel over hills and rolling land the Wind River was reached at a point where it passes through gorgeous masses of rocks known as Red Buttes. The first crossing was made by fording in a diagonal direction up stream where the water was so rapid in its flow that one's neighbor seemed to be moving up the river with the speed of a running horse. Soon by a short ford the river was recrossed and at the end of another mile the western boundary of the Shoshone reservation was reached. From this point our travel was a very interesting, but not too difficult journey over a series of lofty divides, to escape the precipitous banks of small streams flowing from the mountains into the river. In descending one of these it was necessary to dismount and lead the horses.

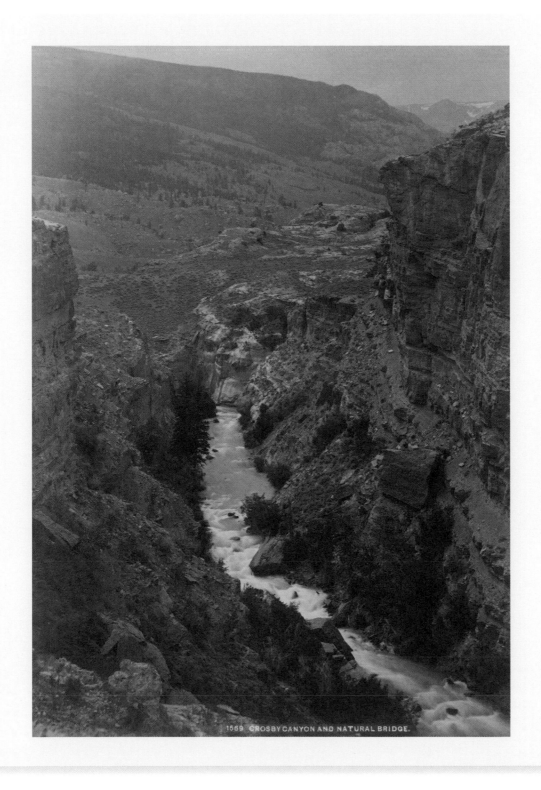

1569 CROSBY CANYON AND NATURAL BRIDGE.

CROSBY CANYON, DINWIDDIE RIVER (1752)
NATURAL BRIDGE, CROSBY CANYON (1755)
CROSBY CANYON, LOOKING SOUTH (1758)

On the highest divide we halted to take in the beautiful view covering scores of miles up and down the river, with the snow-covered peaks of the Shoshone Mountains in front of us, and those of the Wind River Mountains at our backs. Here we took our last look at the great landmark, "Crow Heart Butte," thirty miles away, which had been in view since leaving Fort Washakie. "Wallowing Buffalo," one of our Arapahoe guides, tells us that it got its name from a great battle between the Shoshones and Crows many years ago. The victory of the Shoshones was celebrated by burning the hearts of the dead Crows on the summit of the butte.

After a ride of twelve miles we have reached the banks of some beautiful lakes, which are called after Capt. Torrey, formerly an officer in the army, but now owning large cattle herds on the range near by.[18] The lakes are said to abound in large trout, and we expect to spend to-morrow fishing. Game is not very abundant in this neighborhood, but our hunters brought in two antelopes yesterday, and a few mountain grouse were killed on the march to-day. "Shoshone Dick," a white member of the tribe, who was captured probably from an emigrant train when so young as to have lost all recollection of the event, is one of our Indian party, and has gone off to look for signs of game, and we hope for a good report from him.[19] Our camp is named "Camp Stager," in honor of Gen. Anson Stager, of Chicago.

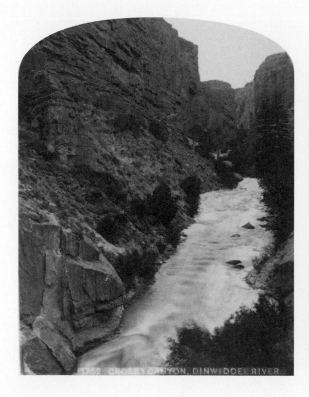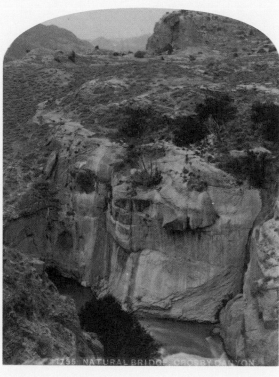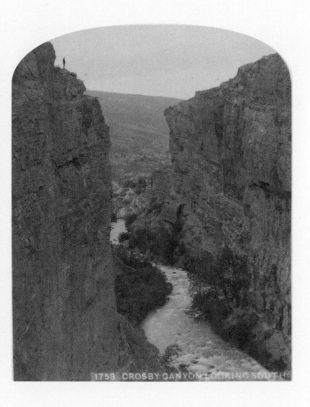

1752 CROSBY CANYON, DINWIDDEE RIVER. 1755 NATURAL BRIDGE, CROSBY CANYON. 1758 CROSBY CANYON LOOKING SOUTH.

CAMP BISHOP, HEAD WIND RIVER (1570)

CAMP BISHOP, FORKS OF THE WIND RIVER, WYO., *Aug. 14,*
via FORT WASHAKIE, WYO., *Aug. 15.—*

The President and party are encamped at the Forks of the Wind River, upon the same ground occupied last year by Gen. Sheridan. The camp was then named Camp Bishop in honor of Mr. H. R. Bishop, of New York, who was a member of the General's party, and the name has been retained for the present camp.[20] Here we remain to-day for the double purpose of affording opportunities for the various members of the party to hunt and fish and to arrange the pack loads. This is our supply camp, whence we have to take on the packs, rations, and forage enough to last through to the Park. At the present moment, whilst the correspondent is writing this dispatch, all members of the party have gone out either hunting or fishing. The President has gone on horseback in company with Gen. Sheridan to a place about three miles up the main fork of Wind River (wrongly called by the people of this country De Noir Creek), where he last evening caught some fine trout. The march of nineteen miles from Camp Stager to this point led us through the beautiful scenery of the Upper Wind River, where gorgeously colored and fantastically shaped mountains alternate with those which are covered with grassy slopes and timbered ravines. The weather is delightful, and the march was thoroughly enjoyed by everybody. Three antelope, a bear, several grouse and a rabbit were brought into camp last evening by the hunters of the party. So there is at present no immediate danger of starvation for anybody. The results of to-day's sport will have to remain over for to-morrow's chronicle.

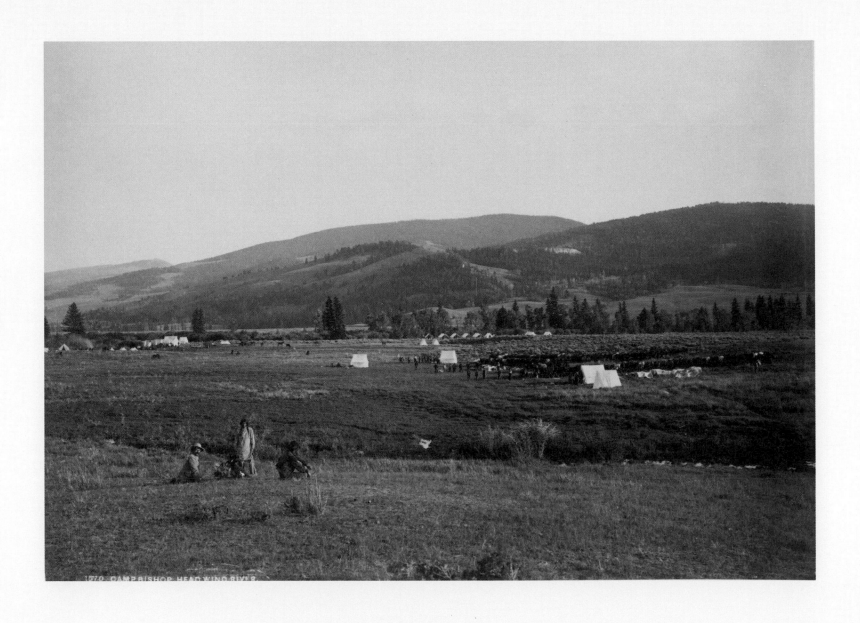

1879. CAMP BISHOP, HEAD WIND RIVER.

PACKER'S CAMP, CAMP BISHOP (1571)

CAMP ROBERT LINCOLN, WYO., *Aug. 15,*
via FORT WASHAKIE, WYO., *Aug. 16.—*

The President's party left the forks of Wind River at 6:30 o'clock this morning, followed the tortuous windings of the river nearly to its source, and then commenced the ascent of Robert Lincoln Pass, used by Lieut. Gen. Sheridan last year and named in honor of the Secretary of War. The pass is the shortest and easiest of the routes between the valley of the Wind River and the valley of the Snake River. The party reached camp at 11 o'clock, having traveled about seventeen miles. The camp is named Robert Lincoln, and is situated on the crest of the backbone of the Rocky Mountains, at an altitude of nine thousand feet above the level of the sea. Within a hundred yards of the camp are streams which flow respectively into the Atlantic and Pacific Oceans.

The President spent part of yesterday trout fishing, and returned to camp with the heaviest catch of the party. The average weight of the trout was two pounds. Surgeon Forwood returned to camp, having shot an elk of enormous size and weight.[21] The other hunters of the party brought in two antelope and a good supply of mountain grouse and wild ducks.

To-morrow morning the party commence the descent of Lincoln Pass, and will camp in the valley of the Gros Ventre River, where the first view of the grand Teton Mountains will be obtained. Game abounds, but Gen. Sheridan has given peremptory orders that no more shall be killed than is absolutely necessary for the wants of the command.

1571. PACKER'S CAMP, CAMP BISHOP.

CAMP BISHOP, HEAD WIND RIVER (1759)
PACKER'S QUARTERS, CAMP BISHOP (1760)
PACK TRAIN CORRAL, CAMP BISHOP (1761)

CAMP ISHAM, GROS VENTRE RIVER, WYO., *Aug.* 16,
via FORT WASHAKIE, WYO., *Aug.* 18.—

The President and party left Camp Lincoln, at Lincoln Pass, this morning at 6:30, and continued the march down a tributary of the Gros Ventre and the main stream a distance of nineteen miles, going into camp at a grassy point on the main river, which has been named Camp Isham, in honor of the Hon. Edward S. Isham, of Chicago.[22] Camp Lincoln was a beautiful spot, presenting to the eye, towards the east and north, all the grandeur of the Shoshone range of snow-clad mountains, and to the west and south the snow-capped peaks of the Gros Ventre range. Pines and tamaracks cover the base and lower lines of the ranges, opening at intervals into beautiful grassy parks.

The descent down the mountains to the valley of the Gros Ventre is rugged, but was accomplished by the President and party without accident, they only dismounting at one steep and difficult place. As we approached Camp Isham a depression in the range enabled us to get a view of the lofty peaks of the Teton range, at the base of which we expect to encamp to-morrow night.

Secretary Lincoln and Capt. Clark, with two Indians, started early this morning in pursuit of elk. They will render no doubt a good account by bringing into camp to-night the results of a fine day's hunt in a country which abounds in game.

The President and remainder of the party, by reason of both the exercise and rest which their trip had given them, are in fine condition, and are not in the least fatigued by their ride on horseback.

The weather is cool, the air delicious and invigorating, and the scenery grand.

PRESIDENTIAL PARTY CROSSING GROS VENTRE RIVER (1572)

GROS VENTRE RIVER, WYO., *Aug. 18, via* FORT WASHAKIE, WYO., *Aug. 19.—*
At 6:30 A.M. the President and party mounted their horses and started from Camp Isham.
We marched down the valley of the Gros Ventre about ten miles, and then crossed that
stream to the north side. Thence the trail lay away from the river through canons and over
mountains of considerable elevation. At one point we wound round the precipitous side of
a mountain, at the base of this nearly perpendicular bank, about 1,000 feet below, the green
waters of the river rolled and tumbled and lashed themselves into a white fury. A stumble,
and horse and rider would have gone headlong to almost certain destruction. Much of
the country of this valley is rolling, the soil rich, and the grasses thick and nutritious. The
Indians with us claim that the snow falls to great depths here in the winter, but there are
evidences that game subsists itself in the valley at that season of the year. In olden times
this region was one of the favorite winter camping-grounds of the Sheep-eater band of
Indians, a branch of the Shoshones, who lived at all seasons near the snow, and subsisted
mainly on the flesh of the mountain sheep or big-horn, which they hunted with dogs and
killed with arrows and clubs.[23]

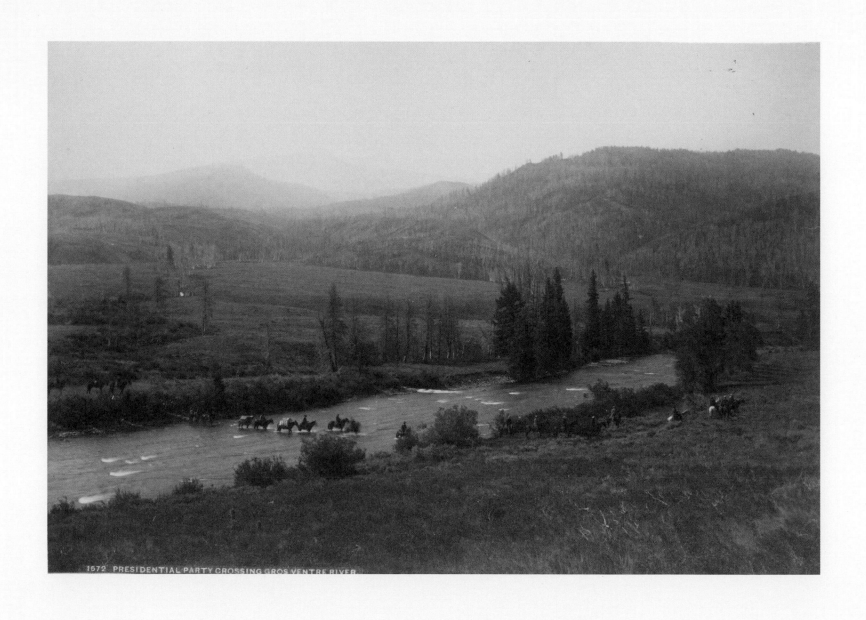

1572 PRESIDENTIAL PARTY CROSSING GROS VENTRE RIVER

The Sheep-eaters have been absorbed by the Shoshones and Bannocks, and now live at agencies, but their old trails can still be seen leading across mountains over which it would seem impossible to take their families and rude belongings. The latter were indeed poor, as they dressed mostly in skins and furs, cooked their meat over the coals and lived in the rocks and caves. One of our guides belongs to this band, but he—an old man now— was a boy when his band gave up this peculiarly wild and savage life.

About fourteen miles out we rose to the crest of a high bluff, from which a most beautiful crescent-shaped little valley met our gaze. Somber pine-clad mountains to the left, at the base of which ran, swiftly and turbulently, the Gros Ventre River, to the right high hills of dark red argillaceous rocks, with here and there ravines filled with foliage; part way down their sides the short bunch grass commenced, thin at first, then thickening to almost a turf when it reached the little mesa below; beyond this some low-lying hills.

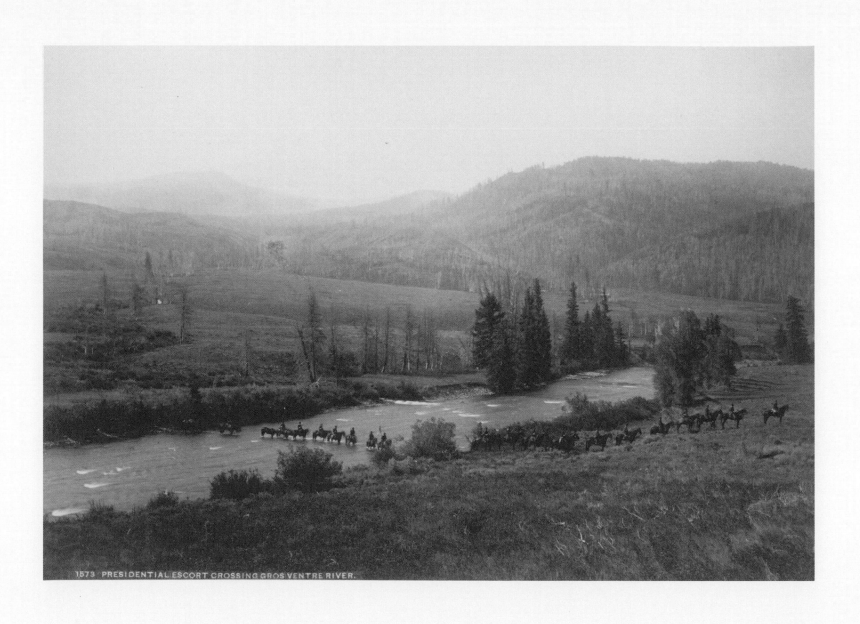

1573 PRESIDENTIAL ESCORT CROSSING GROS VENTRE RIVER.

CAMP ARTHUR, GROS VENTRE RIVER (1575)

The beautiful blue sky above, the dark green mountains to the left, the rich red hills to the right, the russet brown grass of the valley, relieved here and there by the bright green willow bushes and small cottonwoods, the stream of pure cold water made a grand picture of an ideal camp, and with one accord the whole party voted to remain there over night. We rode down, and after our appetites, sharpened by exercise and mountain air, had been satisfied by a hearty luncheon, rods and reels were gotten in shape, and the entire party went fishing. Gen. Stager made the largest catch, Senator Vest next and the President third, but many of those caught by Gen. Stager were white fish, while those of the President and Senator were wholly trout. Enough fish were caught by the members of our party, not only for our own use, but for the soldiers, packers and Indians with us, all of whom had a fish feast. Capt. Clark returned this evening from a two days' hunt after elk and bear. He had but little success. All the party are well and enjoying the fishing, hunting, horseback exercise and mountain air with keenest zest. In honor of the President, Gen. Sheridan named this camp "Camp Arthur."

1675 CAMP ARTHUR, GROS VENTRES RIVER.

THE PRESIDENT'S FIRST TROUT (1764)
PRES. ARTHUR & SEN. VEST'S CATCH OF TROUT (1765)
GEN. STAGER AT TROUT POINT (1770)

CAMP TETON, *Aug.* 18, *via* FORT WASHAKIE, WYO., *Aug.* 20.—

Promptly at 6:30 this morning we mounted our horses, and not without longing, lingering looks behind, rode away from Camp Arthur. Our course was in a westerly direction, along the north side of the Gros Ventre River. The air was clear and bracing, and the day as fine as any with which we have been favored since we set out from Fort Washakie. The trail was beset with few of those difficulties with which our fortnight's travels in the wilderness have made us so familiar. Indeed, in the absence of fallen timber, rocky side-hills and steep ascents and pitches, the ride would have seemed somewhat monotonous but for a single feature which actually glorified it. We had climbed to the summit of a long hill about five miles from Camp Arthur, when there suddenly burst upon our view a scene as grand and majestic as was ever witnessed. Below us, covered with grass and flowers, was a lovely valley many miles in extent, through which was threading its way the river on whose banks we had just encamped. Along the whole westerly edge of this valley, with no intervening foothills to obstruct the view, towered the magnificent Teton Mountains, their snowy summits piercing the air 13,000 feet above the sea level and 8,000 feet above the spot on which we stood in reverent admiration. It was the universal sentiment of the party that that sight alone would have repaid all the toils and perils of the march. We are encamped in the Teton basin on the bank of the Gros Ventre. The locality, aside from the splendid views of the mountains which it affords, is our least attractive camp. The river at this point has an excellent reputation as a trout stream, but the wind has been blowing at too many miles an hour to permit much success in angling. It has been powerful enough to break the ridge-pole of our mess tent, but fortunately not beyond repair.

 To-morrow we shall resume our march and expect to make camp near the so-called Buffalo Fork of the Snake River.

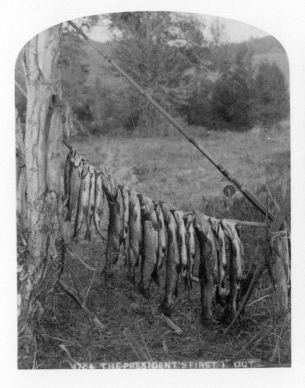

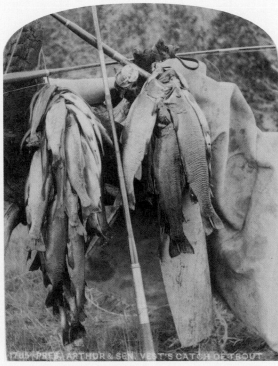

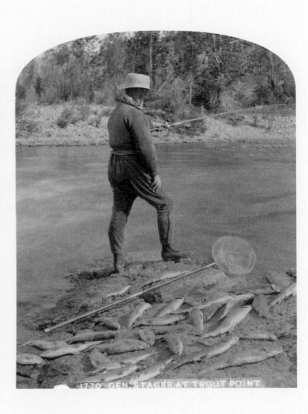

GLIMPSE OF THE TETONS (1576)

The President's party reached this camp after traveling about eighteen miles along foothills between the Shoshone and Teton Mountains. The camp is named in honor of Senator Wade Hampton, who was expected to accompany the party.[24] Its location is grand, being on the banks of the Snake River and facing the entire range of the Teton Mountains. Judge Rollins shot and brought in his first antelope. Nearly all the party are engaged to-day in angling for trout, the President and Senator Vest outstripping the rest, and vying for supremacy. Each landed a two and a half pound trout from the bluff facing the camp, which feats were witnessed by the entire command. Their catch for the day is much larger than on any day during the trip. At our last camp the temper of all the party was severely tried by the extremes of weather experienced. Hot weather in the middle of the day, and severe gales of wind throughout day and night, accompanied with blinding clouds of dust. Ice formed one-half inch thick on water buckets standing before the tents during the night. To-day the weather is clear and bracing, and all the party are in perfect health. To-morrow's march will take us to near the southern boundary of the Yellowstone Park.

GLIMPSE OF THE TETONS.

THE THREE TETONS FROM SNAKE RIVER (1578)

CAMP STRONG, WYO., *Aug. 21, via* BOZEMAN, MONT., *Aug. 22*—

Reveille call at 5 awoke us all from a refreshing sleep, though the ice in our buckets this morning was proof that three blankets had been none too many during the night for our comfort.

Half-past 6 found all the tents struck and packed on the mules, and the Presidential party in the saddle.

Our route to-day of thirty miles lay nearly northward over the foothills of the Shoshone Mountains, avoiding the marshy bottoms of the Snake River, which are very treacherous. It was a rough and rugged country, covered for nearly a quarter of the distance traveled by dense tracks of burned and fallen timber. At noon we reached a sparsely timbered knoll which commanded a view of Jackson's Lake, with the snow-covered Tetons rising from its shores in the background, which repaid us for our severe, hot and dusty march in the early part of the day.

The omniscient reporter who claims to be with us, and who has been purely a mythical personage since we left the railroad at Green River, carefully and considerately located the Secretary of War at Fort Washakie for an indefinite period after we had started on our present trip across the mountains, and as the Secretary has never been absent, it is a matter of much curiosity as to how the inventive genius of this fictitious correspondent would be able to restore him to us.[25] As a matter of fact, Mr. Lincoln has been one of the keenest daily observers of the resources of the country through which we are passing, and is constantly and pleasantly reminding us of his presence.

This evening we are camping at the crossing of Snake River, which was named last year, by Gen. Sheridan, Camp Strong.[26] Our tents are pitched on the banks of the stream in a grove of lofty pines. Trout are abundant, an opportunity the party are taking advantage of, for it is their last for fishing before reaching the Yellowstone region. The surroundings of this camp are beautiful and the opportunity for sport so good that the President has decided that we remain here another day.

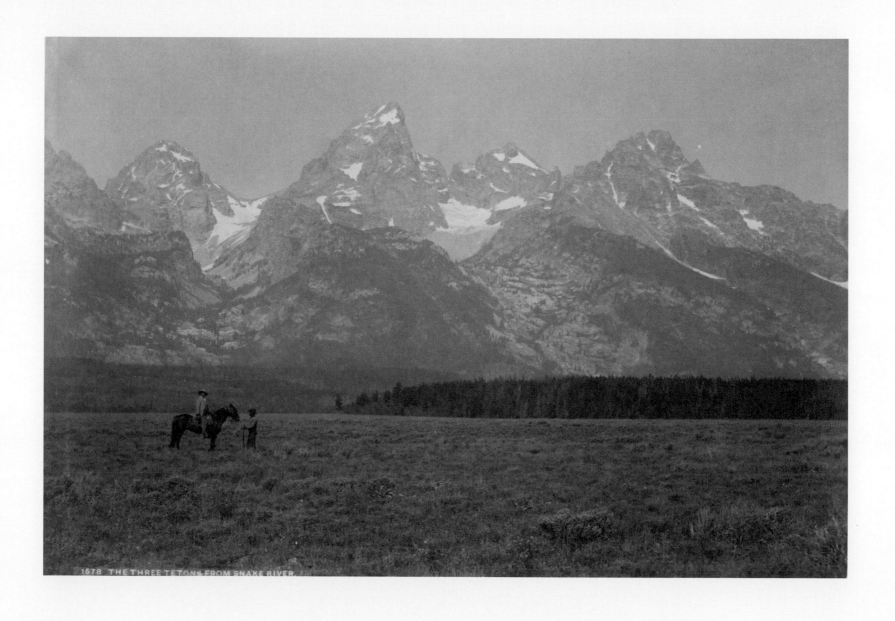

1578 THE THREE TETONS FROM SNAKE RIVER.

THE TETON RANGE AND SNAKE RIVER (1580)

CAMP LOGAN, LEWIS LAKE, *Aug. 23*, *via* LIVINGSTON, *Aug. 25.*—
The white frost was still thick on the blades of grass, leaves, shrubs and plants, and glistened in the morning sunlight like diamond dust, and the mists and vapors rested close on the surface of the river as the Presidential party mounted at 6:45 A.M., and started out for the day's march. Last night was the coldest we have experienced, being 20 degrees Fahrenheit at 6 A.M., and in the mess tent the water which had been served a few minutes before the party sat down for breakfast formed a beautiful network of ice on the inner surface of the glasses.

The trail was very crooked to-day, and led over a low range of mountains covered with pine forests. At intervals we found open, grassy parks, but the most of them were only a few acres in extent. About twelve miles out we came upon the lower falls of Lewis or Lake Fork, a dark gray gorge cut through solid walls of volcanic rock, its sides nearly perpendicular. About 600 feet below us the stream rushed and tumbled over its dark bed, broken white by its fretting. The upper falls, some six miles from the lower, we saw at a distance through an opening in the evergreen trees; it seemed to drop from out the dark foliage behind it like a flood of lace. Five miles further on we went into camp in a lovely open park at the head of Lewis Lake, the only spot on the shore line which is not densely timbered.

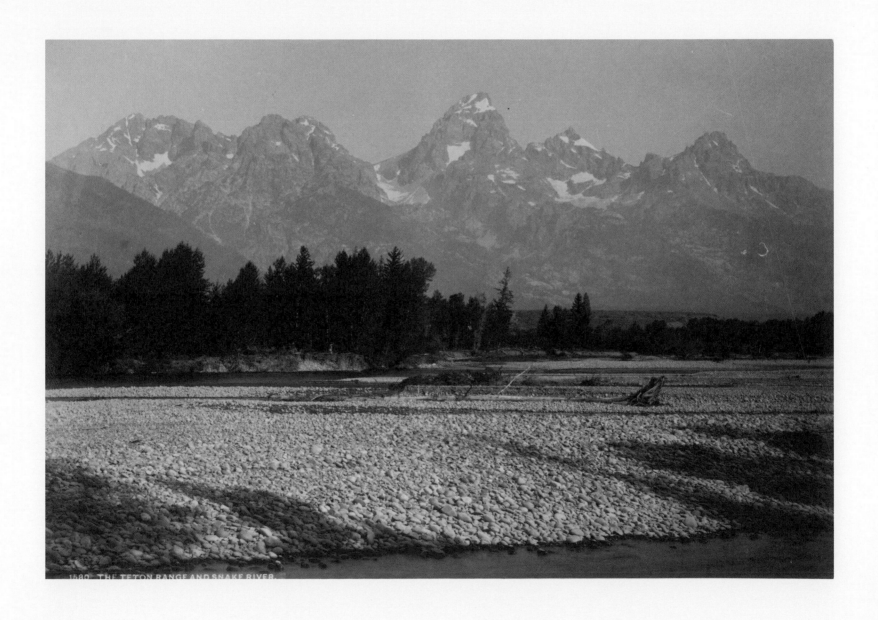

1580. THE TETON RANGE AND SNAKE RIVER.

THE GRAND TETON (1776)
TETON RANGE, SNAKE RIVER VALLEY (1777)
MT. MORAN AND LEIGH LAKE (1779)

The camp has been named Logan, in honor of the Senator, who was to have been one of the party, and whose unavoidable absence we have all regretted.[27] Our tents look out on this beautiful sheet of water. The sound of the swirl of the waves on the beach mingles pleasantly with its twin sister sound, the soughing of the winds in the trees near by.

Along our line of march to-day we saw large quantities of Indian tea, diminutive species of evergreen whortleberries five to ten inches high, found only in timber and at an altitude of from 8,000 to 10,000 feet. The Indians are fond of the tea made from the dried leaves and stems of this plant, and I have been told by those who have drunk it that it forms a pleasant substitute for our own.

Yesterday we remained at Camp Strong, and its surroundings are worthy of more than a passing notice. A grassy bottom surrounded by mountains clad with evergreens, trees of all sizes from the young seedling up to mature age, scattered single, grouped in clusters, or massed into dark forests. Our tents were pitched on the banks of Snake River, which here possesses all the attributes of a first-class trout stream. Clear, pure water rippling over pebbly bottoms, with here and there swift currents, eddies and deep holes. The President and Senator Vest, our two most expert fishermen, made the best of our stay, and scored the greatest victory yet achieved over the finny tribe.

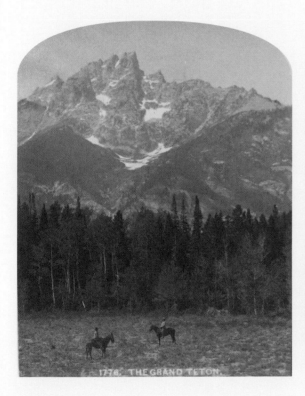

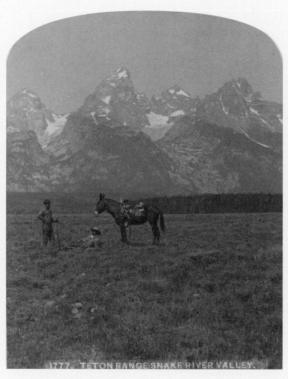

1776. THE GRAND TETON.

1777. TETON RANGE SNAKE RIVER VALLEY.

1779. MT. MORAN AND LEIGH LAKE.

CHIEF PACKER MOORE (1780)
PACK TRAIN MASTERS (1781)
THE FAVORITE MULE (1782)

At one cast the President landed three trout, weighing in the aggregate four and one-quarter pounds, and at each of some six other casts took two fine specimens. The President secured the greatest weight, the Senator the largest number, the total weight being 105 pounds. The sport is now about over. Senator Vest has caught the largest trout during the trip, it weighing three and one-half pounds.

Looking back over our course from Fort Washakie, where we first mounted our horses, abandoned wheeled vehicles, and took the Indian trail which has led us through some fertile valleys, across some bad lands, and over rugged mountains, many memories linger pleasantly in the mind of every member of the party. The hailstorm at Camp Crosby, the dust which sifted in our tents at Camp Teton, the trails of fallen timber, are lost and forgotten in the pleasant associations of the rest of the journey.

Picturesque Camp Lincoln, with its banks of snow lying placidly and slowly melting near the trail, and near the snow-flowers, which had all the freshness of early spring, tender forget-me-nots, wild asters, buttercups, columbines, the latter with a delicate and scarcely perceptible shade of blue in its rich white, and for which many deem it the most beautiful of the wild flowers found in the Rocky Mountains, a carpeting of scarlet and blue and gold; added to this the White Mountain flox [phlox], nestling close to mother earth, and in such profusion as to suggest the idea that the hand of Nature had grasped some of her myriad stars and scattered them in wanton profusion on the grassy slopes of this romantic region.

1780. CHIEF PACKER MOORE.

1781. PACK TRAIN MASTERS.

CAMP HAMPTON, TETONS IN DISTANCE (1582)

Camp Arthur, grand beyond the power of pen to describe, located in a bend of the Gros Ventre River, and looking down upon it from the crest of the hill over which the trail led, we also got the first good view of the royal Tetons, or Titans, as they should be called. To the west forests of pine and spruce mantling the mountains. To the south and east clay and sand stone rising high in the sky, and rich red from its iron coloring, masked here and there by green foliage. The short, thick grass of the little valley furnished splendid grazing for our animals, and the trout, within twenty feet of the tents, made the immediate surroundings most delightful. Then the Teton basin, large as the state of Rhode Island, and covered at this season of the year with nutritious grasses, and profuse in evidences of being the winter grazing grounds of antelope, deer, and elk. The near future must practically determine its value for stock purposes. Then Jackson's Lake, as we saw it from the crest of a high bluff on our line of march, a gigantic sapphire, its surface fretted and blown into white-caps by the winds which swept down over Mount Moran, and moanings lost themselves in the gloomy forests beyond.

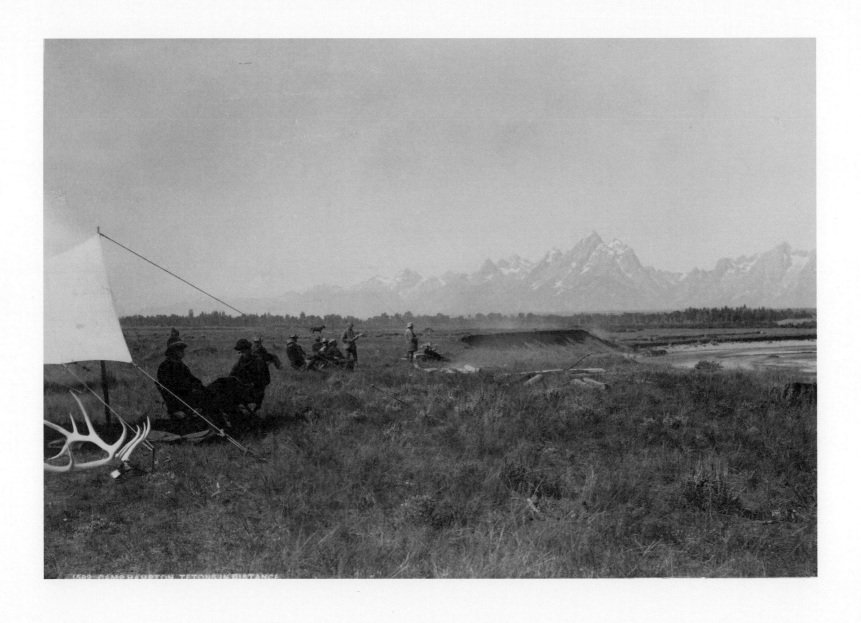

CAPT. HAYES' QUARTERS, CAMP HAMPTON (1583)

Nature has indeed given a royal setting to this jewel, twelve miles long, three miles wide—
on the east and north a fringe of quaken asp[en] and willow brush, on the west and south
spruce and pines clothing the feet of the grand Tetons and scrambling up their sides until
vegetation dies out. Above this the fissures and chasms of the grim, gray pile of rocks, filled
with snow-banks, some of them 3,000 feet deep and of dazzling whiteness in the sun. Yes,
the scenery along our route will furnish many pleasant memories in the years to come.

Enough game has been killed to satisfy the wants of the party, but to-day we entered
the sacred precincts of the park, and the buffalo and elk can look at us with perfect safety,
for Gen. Sheridan has given strict orders that nothing shall be killed.[28]

The members of the party are enjoying their usual good health—are commencing, in
fact, to realize something in the way of robust strength for the investment made in taking a
trip of this kind.

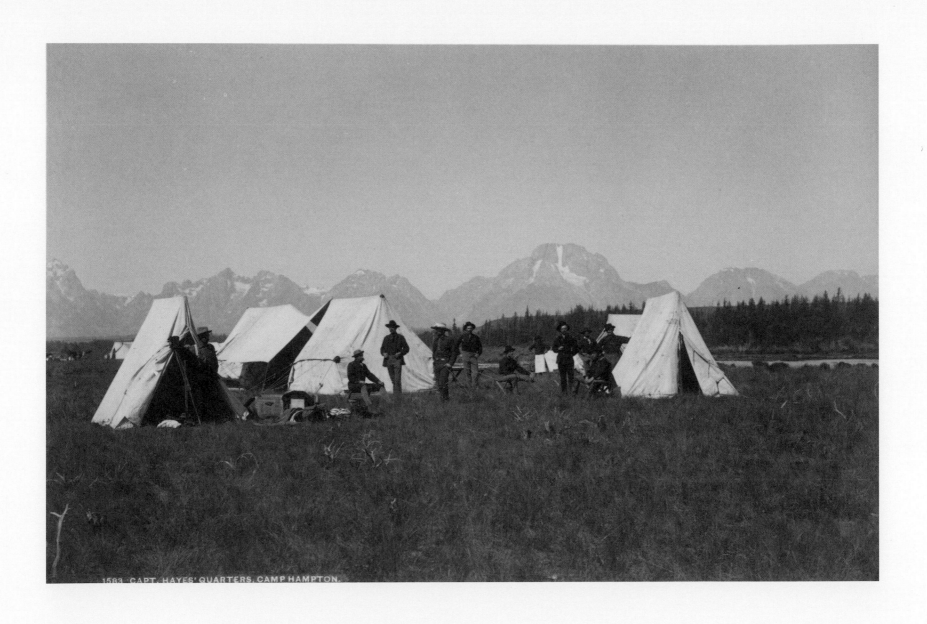

1583 CAPT. HAYES' QUARTERS, CAMP HAMPTON.

A GLIMPSE OF THE GEYSER BASIN (1051)

GRAND GEYSER CONE—UPPER BASIN (1038)

IMPROVEMENT CO'S. QUARTERS, UPPER BASIN (1461)

UPPER GEYSER BASIN, YELLOWSTONE NATIONAL PARK, *Aug. 24,*
via LIVINGSTON, MONT., *Aug. 26.*—

At 1 o'clock today, after a dusty march of twenty-six miles over a rough trail, the President
and party arrived in Upper Geyser Basin of the National Park, and went into camp near Old
Faithful Geyser, who greeted us a few moments after dismounting with one of its hourly
eruptions. All of us were very tired and hungry, and the exhibition that seemed specially to
greet the Chief Magistrate could induce but few of our number to abandon their lunch and
rush to a point for observing the display.

 This afternoon was devoted to resting, bathing, and overhauling our outfit, and but little
attention was paid to the Geysers beyond those in the immediate vicinity of our camp. All
are impressed with wonder at what surrounds us, and to-morrow will no doubt prove a day
of interest and pleasure. Of the curious freaks that Nature exhibits in this section I shall
say nothing. The whole park and all it contains have been often described, and I would not
undertake to write up that which has been so well pictured by Barlow, Doane and others.[29]
After our ride on horseback of 230 miles every member of the expedition is in the best of
health, and not an accident of the slightest character has occurred on the whole journey to
mar our pleasure.

1051. A GLIMPSE OF THE GEYSER BASIN.

1038. GRAND GEYSER CONE—Upper Basin.

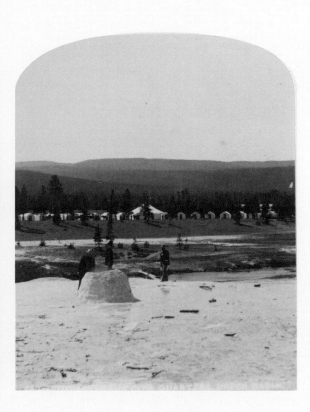

PRESIDENTIAL PARTY AT LUNCH (1584)

YELLOWSTONE LAKE, *Aug. 26*, *via* LIVINGSTON, MONT., *Aug. 28.*—
It was the intention of the President's party to remain over Sunday at Upper Geyser Basin until it was ascertained that the vicinity of the camp offered insufficient forage for the animals. This discovery made it necessary to resume our march this morning. We broke camp at the usual hour, and returning to Shoshone Lake by the same trail over which we rode Friday, proceeded thence in an easterly course to the Yellowstone Lake, on whose borders we are now encamped. Our journey to-day has been somewhat tiresome. Its difficulties can perhaps be most effectually summarized in the statement that we have twice crossed the Continental Divide in the space of twenty miles. For the toils of the march we have, however, received abundant compensation since we halted. Our camp is in one of the most attractive spots which has greeted our eyes since we began our tour through the wilderness. It affords us a view across the widest breadth of a more magnificent sheet of water than any other of equal altitude in the known world.

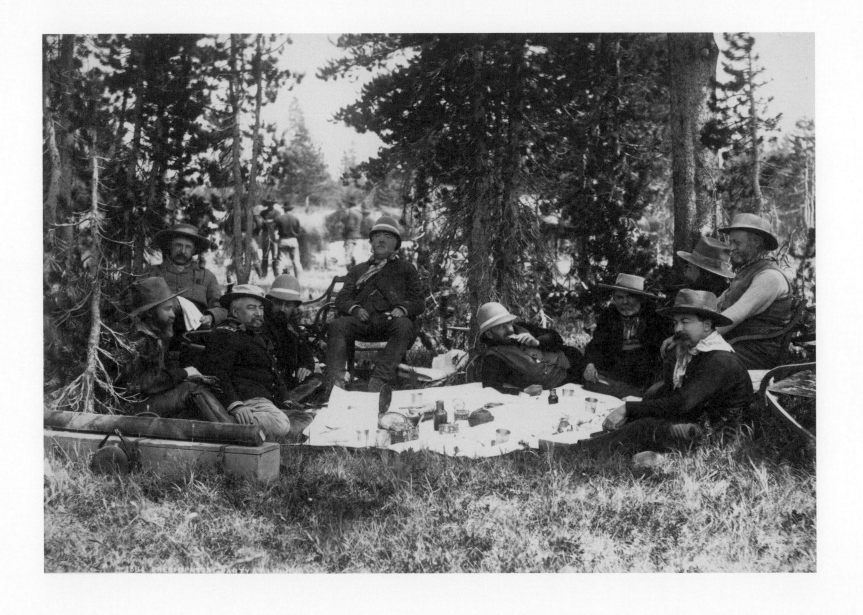

OLD FAITHFUL IN ACTION (1458)
CAMPING POINT—YELLOWSTONE LAKE (1070)
PETRIFIED INDIAN—YELLOWSTONE LAKE (1072)

It has given some of our party an opportunity to verify the truth of a statement which has been often made, but widely doubted, that it was possible to capture a trout in the waters of this lake, and without detaching it from the hook to fling it into an adjacent geyser and bring it forth cooked.[30] It is not generally known that this locality abounds in those natural phenomena which are the chief attraction of the Lower Geyser Basin. The paint-pots of that region here find worthy rivals, and within a hundred yards of our encampment mud geysers are constantly busy fashioning the curious creations which have been so frequently described by tourists. A few steps from these geysers are hot springs of various sizes and temperatures. Their waters are clear as crystal and close to their edges grow flowers as rich in color and as dainty in structure as those which carpeted Camp Lincoln. The day has been crowned by a sunset which has glorified the summits of the distant mountains, and the "shining levels of the lake." With the darkness has come a refreshing rain, the first which has visited us for many days. While not serious enough to cause annoyance or inconvenience, it will suffice to rob to-morrow's march of the dust and heat which have given to that of to-day no small part of its discomfort.

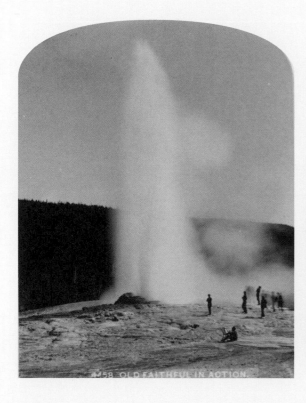

CAMP CAMPBELL, FOOT OF YELLOWSTONE LAKE, WYO., *Aug. 27.*—

The President and party arrived at this camp about noon to-day, having marched from the most southwesterly point of the lake a distance of twenty-two miles. The trail by which we came over winds around the borders of the lake almost entirely through timber, and the agreeable shade and absence of dust made the ride one of the most enjoyable of the whole journey.

At the point where we remain to-night there is abundant and nutritious grass. Our camp is in the fringe of the fine pine timber which covers the mountain-sides, and is elevated enough to overlook the splendid meadow upon which our animals are feeding, and to command a comprehensive view of the lake whose waters wash the precipitous cliffs of the Shoshone Mountains beyond. Many of the peaks are snow-capped, and by the light of the setting sun are made visible for many miles.

The President, accompanied by Capt. Clark, went fishing this afternoon, whilst the rest of the party were contented to rest and enjoy the panorama spread before them. The President caught thirty-five fish, weighing forty-five pounds. The head of an extinct species of rhinoceros and two vertebrae of a large fossil saurian, in an excellent state of preservation, were found on the bank of the lake near our camp by our surgeon and naturalist, Major W. H. Forwood. The specimens are interesting, and will be sent to Prof. Cope, of Philadelphia.[31]

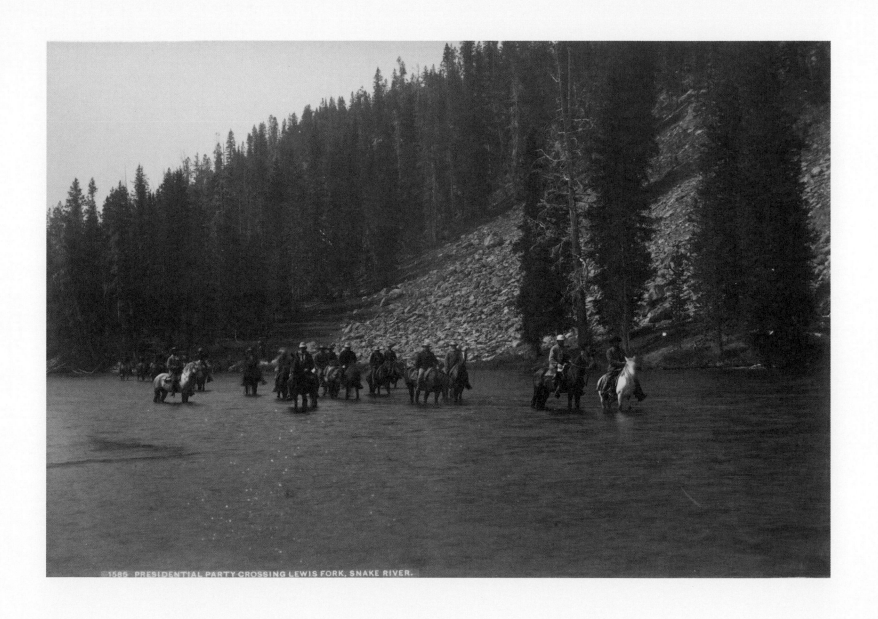

1585 PRESIDENTIAL PARTY CROSSING LEWIS FORK, SNAKE RIVER.

PRESIDENTIAL PARTY, UPPER GEYSER BASIN (1586)

CAMP ALLISON, YELLOWSTONE FALLS, *Aug. 28,*
via LIVINGSTON, MONT., *Aug. 30.*—

Leaving the Yellowstone Lake at 6:25 this morning, the President's party journeyed eighteen miles over a splendid trail to this point. The road was equal to any turnpike in the states, and on the way the party halted at the wonderful mud geysers. One of them is known as "Editor's Hole," and one as "Devil's Caldron." As we looked into the first and listened to the rush and roar of the seething water and mud that eternally boils, but finds no outlet, it was generally remarked that the place was properly named.[32] The canon of the Yellowstone, on which we are now camped, surpasses description in grandeur. The two falls between which we have pitched our camp are equal in sublimity and beauty to any upon the continent. Leaping and rushing between precipices of red and yellow rock, the Yellowstone River seems to tear its way through the solid mountains, leaving in its pathway forms of uncouth and awful majesty seen nowhere else. Mingled with these scenes of nature, we find here also the inevitable tourists, male and female, each of whom is anxious to see not only the canon but the President, and it is wickedly suggested by some that the eyes of these lovers of nature are directed more frequently to the latter than to the former. We will probably remain here to-morrow, and expect to reach the railroad September 1st.[33] So far the trip has been one of unalloyed pleasure, and all are in the best of health.

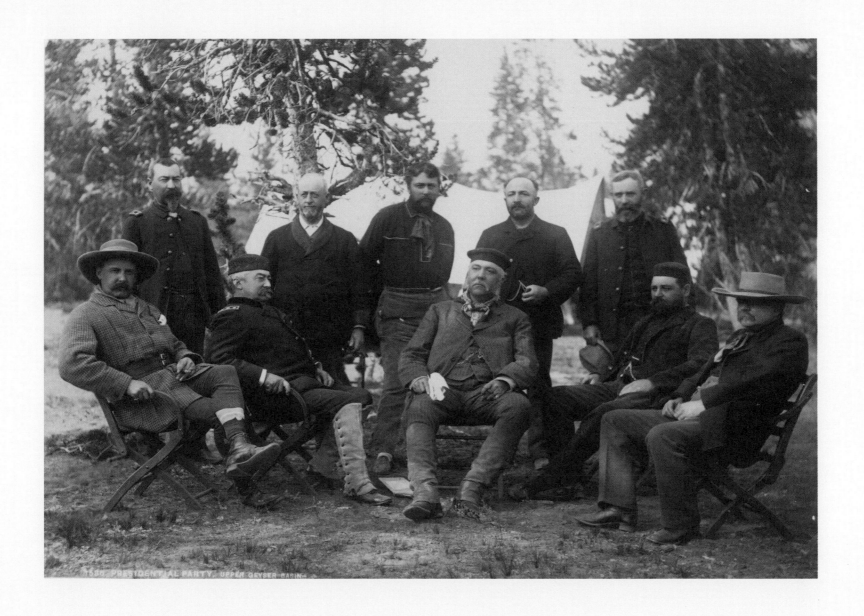

THE RAPIDS ABOVE THE UPPER FALLS (1281)
GREAT FALLS OF THE YELLOWSTONE, 360 FEET (1076)
GRAND CANYON OF THE YELLOWSTONE (1095)

CAMP ALLISON, YELLOWSTONE CANON, *Aug. 30.*—

The President and party remained at Camp Allison yesterday so that an excursion could be made to the neighboring points of view from which the Grand Canon and great Falls of the Yellowstone can be seen.[34] Our camp was in a beautiful grove, and the day was very interesting, but uneventful. We start for Tower Falls this morning.

As our trip is drawing to its end, this is probably as good an opportunity as will be presented to refer to the inventions of newspapers which have continuously published pretended special telegrams purporting to be from correspondents with our party. No special correspondents have been with us. The falsehoods of these pretended specials are apparent to any one knowing the distances to be traveled in this region, as the correspondents seem to transfer themselves and to send their reports in one day over distances which cannot possibly be passed in three or four days.

Their silly stories of personal incidents are not of sufficient consequence to be denied, but stories of danger to the President and of his being in bad health go beyond the bounds of permissible hoaxes as misleading the public in a matter of general interest, and for this reason it should be known that there has not been at any time the slightest ground for any such stories. The President is and has continuously been perfectly well, and has traveled the whole journey on horseback, being excelled by none in his enjoyment of our marches and camp life. The only other falsehood worthy of mention as being on a subject of public interest is that on this journey any attention has been given by the President, Secretary of War, or Gen. Sheridan to a new policy of dealing with the Indians. If such matters were to be dealt with, the Secretary of the Interior would have been present, and it is sufficient to say that many newspapers have been fighting a man of straw. A simple illustration of the deceptions of these specials is found in their having made our party arrive at the Upper Geyser Basin on a day when we were four days' march distant from it.[35]

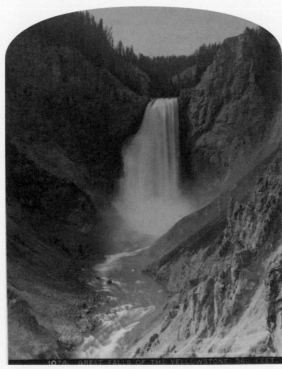

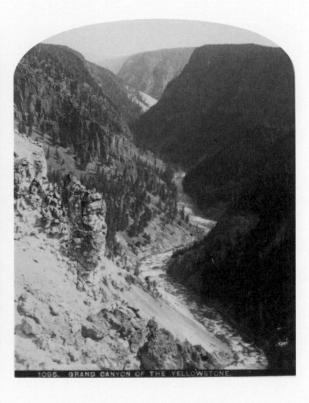

1281 THE RAPIDS ABOVE THE UPPER FALLS.

1078. GREAT FALLS OF THE YELLOWSTONE 360 FEET.

1095. GRAND CANYON OF THE YELLOWSTONE.

TOWER FALLS—NEAR YELLOWSTONE RIVER (1103)

FALLS OF THE WEST GARDNER, 75 FT. (1806)

INTERIOR MAMMOTH CAVE (1796)

CAMP CAMERON, BARONETT'S BRIDGE,
via LIVINGSTON, MONT., *Aug.* 31.—

Camp was broken as usual at 6:30 yesterday morning, and all of the party, rested and invigorated by a day's sojourn amongst the grand scenery about the Canon and Falls of the Yellowstone, gladly took the trail leading northward to our last camp on the banks of the famous river.

There are two trails leading from the lower falls to Baronett's Bridge. One follows the canon, along its brink, for five or six miles, then leaves it and passes to the eastward of Mount Washburn. It is a very difficult route, the last twelve miles of which are a constant descent. The other and better one we followed, and passed over the westward slope of the same mountain.[36]

From the summit of Mount Washburn, 10,000 feet above the sea, an extended and comprehensive view of the park scenery was obtained. To the northward and east the grand, serrated and snowy ridges and peaks of the Rocky Mountains rise to the sky. To the eastward and south great banks of snow lay low upon the peaks of the Shoshone Range. The Grand Canon, from this point of vantage, looks like a narrow gorge fringed with dark pines. In the distance can be seen some of the great geysers sending forth puffs of steam and giving their locations the appearance of an aggregation of busy factories.

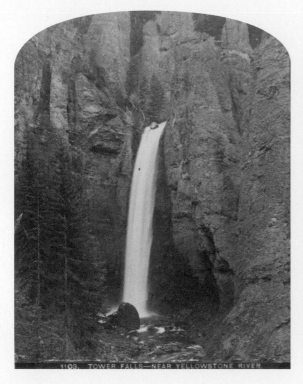

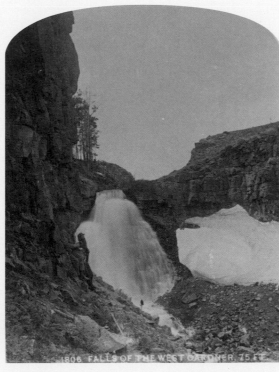

CLEOPATRA'S BOWL. MAMMOTH SPRINGS (1412)

FORMATION AT MAMMOTH HOT SPRINGS (1238)

FALLS OF THE GIBBON (1259)

The gray volcanic rocks which crown the summit of the mountain are relieved at intervals by grassy slopes, and upon them are sprinkled beds of lovely wild flowers.

In a cairn of stones which is at the very top of the mountain those who have had the courage to make the ascent have left their cards with notes, some giving most wretched accounts of the experiences of the writers, the results of the cold winds, snow and sleet which had greeted them, and while making them bodily miserable had also shut off from their eyes the splendid landscapes which they had climbed so far to see.

The President and Senator Vest tried their luck at fishing yesterday afternoon after our rather trying ride of twenty-one miles over a rough mountain trail, and were respectively rewarded by a catch of eight and six fine trout.

Our camp is named Camp Cameron by the President in honor of the Senator from Pennsylvania.[37] It is situated on a grassy slope beside a grove of aspens, and overlooks the valley of the river upon which our herds are peacefully grazing. To-day's march is over a wagon-road to the Mammoth Hot Springs, and to-morrow we expect to reach the terminus of the branch road of the Northern Pacific Railroad.

BATH LAKE, MAMMOTH HOT SPRINGS (1793)
SOUTH HOT SPRING BASIN (1014)
COATING TERRACE, HOT SPRINGS (1003)

MAMMOTH HOT SPRINGS, WYO., *via* BILLINGS, MONT., *Sept.* 1.—

We began our day's march yesterday morning at the usual hour. During the previous night sufficient rain had fallen to lay the dust on the wagon road by which we traveled and to rob our journey of all the discomforts which would else have attended it. Our route to-day lay through a portion of the park as yet little visited by tourists, but scarcely less interesting than other sections which are more widely known and admired. The view of the Gardner River and Falls, as seen from the roadside half a mile below, can never be forgotten by any who have been so fortunate as to enjoy it. The Mammoth Springs presented a very interesting appearance from the moment when the white basin which they have builded [*sic*] for themselves on the mountain side greeted our eyes. It is this elevated basin, rather than its contents, that justifies the term Mammoth as descriptive of the hot springs in this region. The enormous spring, a few rods from the Sheridan Geyser, is much larger than any which is here to be seen, and pours out a far greater volume of water.

We encamped in an enclosed lot near the residence of the Park Superintendent.[38] Some of our party made haste to enjoy the luxury of a hot bath, and others visited the hotel, 300 yards away. Senator Vest and Governor Crosby remained at yesterday's camp to fish, and after capturing seventy-five fine trout rejoined us this afternoon.

The great camp-fires of logs and fallen timber had been lighted but a few moments, and its glare was throwing the dark green foliage of the pines into bold relief, when a party of tourists from the hotel called to pay their respects to the President, and entertained us with some excellent music. In this quartette were Mrs. Fisk, of Buffalo, contralto; Mr. Hermann, basso, and Messrs. Ellard and Dennison, tenors. Then followed duets by the Misses Robertson, of London. "The Banks and Braes of Bonnie Doon" and the "Venetian Bird Song" (the latter written expressly for these charming vocalists), were rendered with exquisite harmony. The entire party then adjourned to the hotel, where an informal reception was held, and more music thoroughly enjoyed.[39]

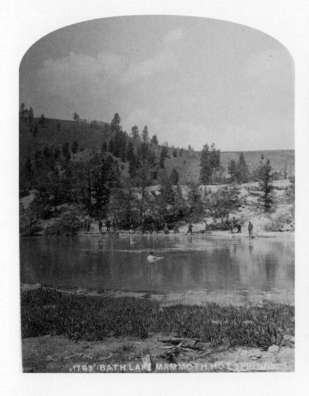

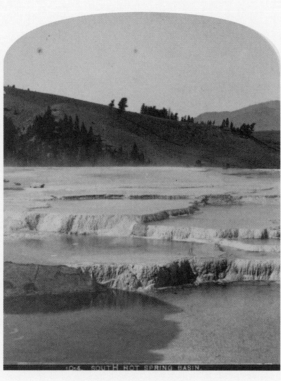

1793 BATH LAKE MAMMOTH HOT SPRINGS

104 SOUTH HOT SPRING BASIN.

1003 COATING TERRACE, HOT SPRINGS.

The march of 350 miles is finished. The last camp-fire has been lighted and has burned to ashes, and to-day the party take the train awaiting them seven miles away, and start for Livingston, on the main line of the Northern Pacific Railway.[40]

Governor Crosby returns to his post of duty at Helena. Senator Vest begins a journey through Montana and Dakota, visiting various Indian agencies, in pursuance of his duties as a member of the joint committee of Congress of which Senator Dawes is Chairman.[41]

The President and other members of the party proceed to Chicago, where they will arrive Tuesday morning.

———◆———

BILLINGS, MONT., *Sept. 1.*—

The President and party passed this point at 3 P.M. The special train will arrive at Fort Keogh at midnight, St. Paul Monday evening, and Chicago Tuesday.[42] All are well. This is the last telegram you will receive from the representative of the Associated Press accompanying the Presidential party.

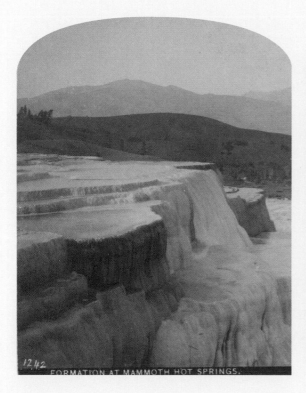

FORMATION AT MAMMOTH HOT SPRINGS.

FORMATION AT MAMMOTH HOT SPRINGS.

1275 CRYSTAL FALLS.

APPENDIX

The thirty-five photographs in this appendix were included in the
Haynes album owned by President Chester A. Arthur.

IMPERIAL VIEWS BY FRANK JAY HAYNES FROM PRESIDENT ARTHUR'S EXPEDITION

CROSBY CANYON, DINWIDDIE RIVER
(1567)

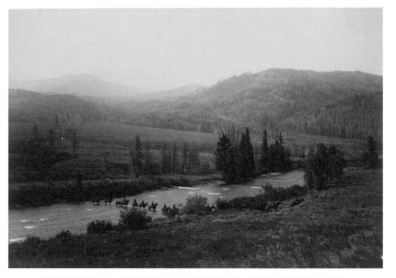

PRESIDENTIAL COURIER LINE CROSSING GROS VENTRE RIVER
(1574)

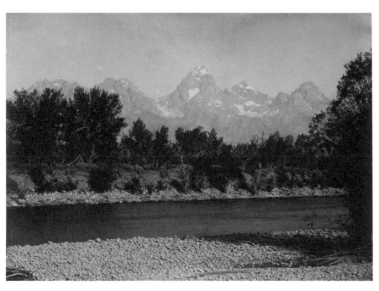

TETON RANGE FROM SNAKE RIVER
(1577)

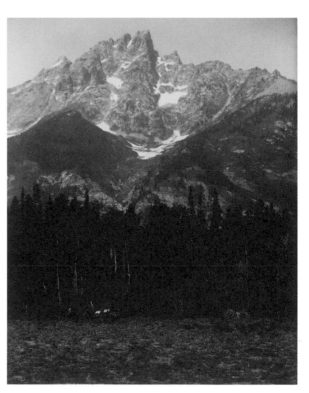

THE GRAND TETON
(1579)

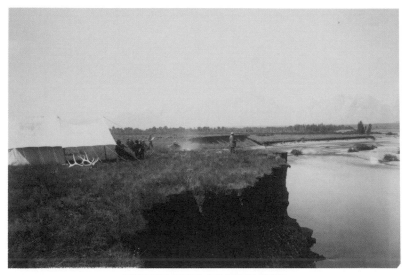

CAMP HAMPTON ON SNAKE RIVER
(1581)

SMALL-FORMAT VIEWS BY FRANK JAY HAYNES FROM PRESIDENT ARTHUR'S EXPEDITION

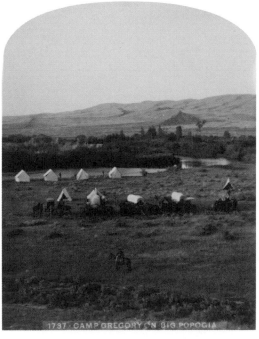

CAMP GREGORY ON BIG POPOGIA
(1737)

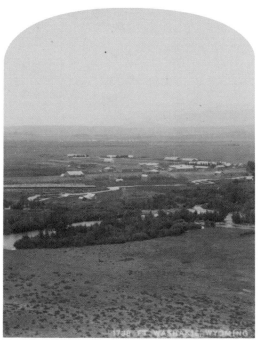

FORT WASHAKIE, WYOMING
(1738)

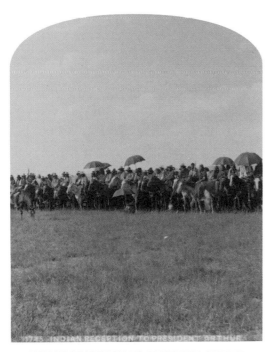

INDIAN RECEPTION TO PRESIDENT ARTHUR
(1745)

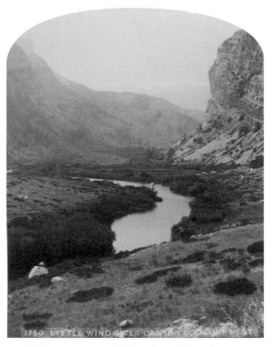

LITTLE WIND RIVER CANYON LOOKING WEST
(1750)

LITTLE WIND RIVER CANYON LOOKING EAST
(1751)

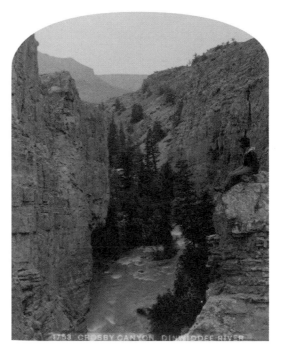

CROSBY CANYON, DINWIDDIE RIVER
(1753)

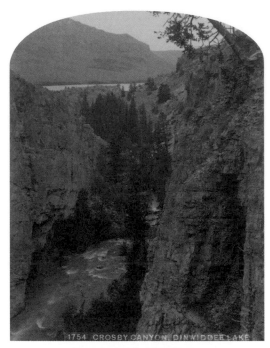

CROSBY CANYON, DINWIDDIE LAKE
(1754)

CROSBY CANYON AND NATURAL BRIDGE. WEST
(1756)

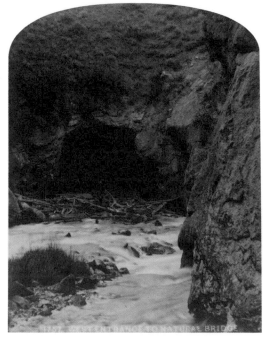

WEST ENTRANCE TO NATURAL BRIDGE
(1757)

ELLEN'S PEAK, WIND RIVER RANGE
(1763)

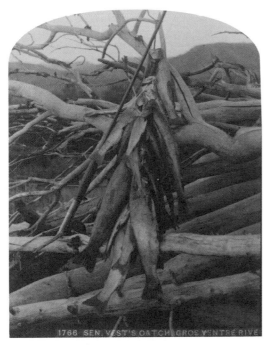

SEN. VEST'S CATCH, GROS VENTRE RIVER
(1766)

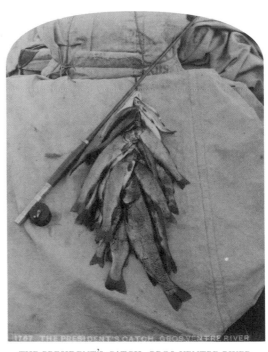

THE PRESIDENT'S CATCH, GROS VENTRE RIVER
(1767)

LARGEST AND SMALLEST TROUT CAUGHT
(1768)

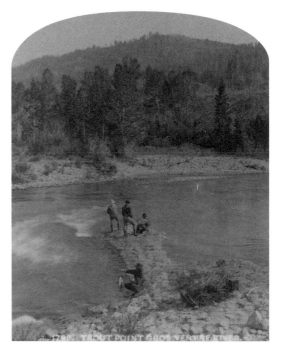

TROUT POINT, GROS VENTRE RIVER
(1769)

CAMP ARTHUR, GROS VENTRE RIVER
(1771)

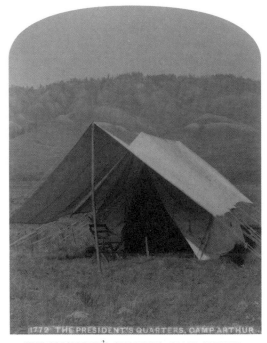

THE PRESIDENT'S QUARTERS, CAMP ARTHUR
(1772)

FIRST VIEW OF THE TETONS
(1773)

GLIMPSE OF THE TETONS
(1774)

GLIMPSE OF THE TETONS
(1775)

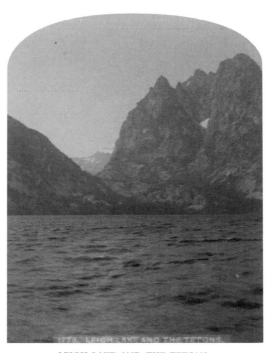

LEIGH LAKE AND THE TETONS
(1778)

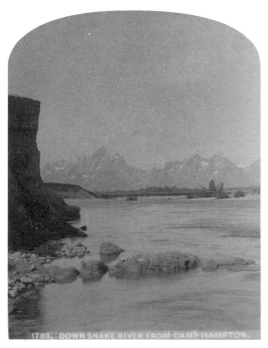

DOWN SNAKE RIVER FROM CAMP HAMPTON
(1783)

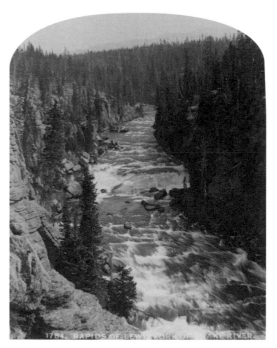

RAPIDS OF LEWIS FORK OF SNAKE RIVER
(1784)

OTHER SMALL-FORMAT VIEWS FROM EARLIER AND LATER PHOTOGRAPHIC EXCURSIONS
BY FRANK JAY HAYNES

GROTTO GEYSER CONE—UPPER BASIN
(1037)

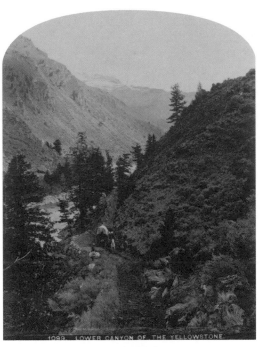

LOWER CANYON OF THE YELLOWSTONE
(1099)

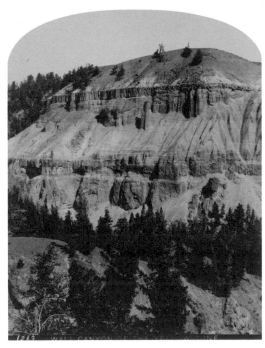

WALL CANYON OF THE YELLOWSTONE
(1263)

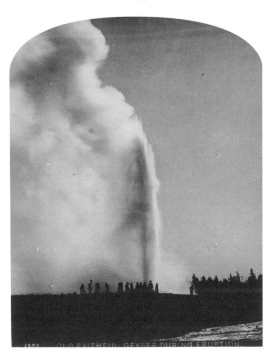

OLD FAITHFUL GEYSER DURING ERUPTION
(1303)

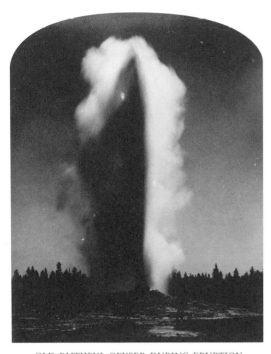

OLD FAITHFUL GEYSER DURING ERUPTION
(1306)

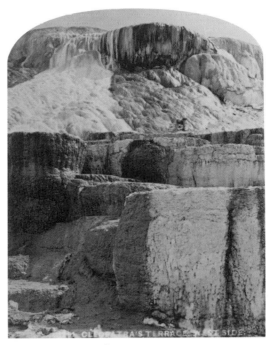

CLEOPATRA'S TERRACE, WEST SIDE
(1791)

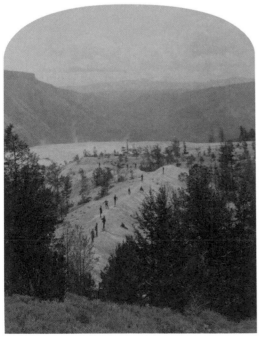

NARROW GAUGE TERRACE
(1799)

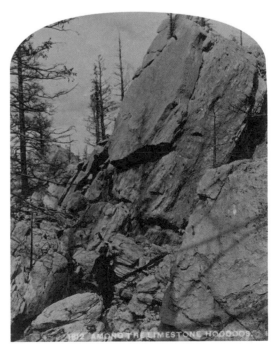

AMONG THE LIMESTONE HOODOOS
(1812)

NOTES

INTRODUCTION

1. Previous histories of President Arthur's Yellowstone trip include the following: Hartley, *Saving Yellowstone*; Haynes, "Expedition of President Chester A. Arthur to Yellowstone"; and Reeves, "President Arthur in Yellowstone."

2. Grinnell, "Our Angling President."

3. Reeves, *Gentleman Boss*, 317.

4. Chester A. Arthur to Alan Arthur, March 11, 1883, letter, Arthur Papers.

5. Charles M. Hendley, "Recollection of Chester Alan Arthur, April 22, 1925," manuscript, Arthur Papers.

6. Philip H. Sheridan to Frederick J. Phillips, June 14, 1883, letter, Sheridan Papers.

7. "The Bee," *Cincinnati Enquirer*, November 22, 1883: 1.

8. Philip H. Sheridan to Robert Todd Lincoln, July 27, 1883, letter, Sheridan Papers.

9. [Untitled], *Rocky Mountain News*, July 9, 1883, 4.

10. "Washington: President Arthur Will Spend His Vacation Entirely in the West," *Chicago Tribune*, July 16, 1883, 1.

11. "The President's Trip," *Chicago Tribune*, July 24, 1883, 8.

12. "President Arthur," *New York Herald*, July 24, 1883, 3.

13. Charles M. Hendley, "Recollection of Chester Alan Arthur, April 22, 1925," manuscript, Arthur Papers.

14. Haynes, "Expedition of President Chester A. Arthur to Yellowstone," 32.

15. On the life and photography of Frank Jay Haynes, see Montana Historical Society, *Frank Jay Haynes, Photographer*; and Freeman Tilden, *Following the Frontier with F. Jay Haynes*.

16. Henry M. Teller to Frank Jay Haynes, February 26, 1883, letter, Frank Jay Haynes Papers, collection 1500.

17. Carroll T. Hobart to Frank Jay Haynes, May 5, 1883, letter, Frank Jay Haynes Papers, collection 1500.

18. Thomas, "My Recollections of Yellowstone."

19. Frank Jay Haynes to Lily Snyder Haynes, August 4, 1883, letter, Jack Ellis Haynes Papers, collection 1504.

20. Haines, *Yellowstone Story*, vol. 2, 478.

21. On Yellowstone's history during the summer of 1883, see the following: Barringer, *Selling Yellowstone*, 25–28; Bartlett, *Yellowstone*, 43–53; Haines, *Yellowstone Story*, vol. 1, 261–326; and Magoc, *Yellowstone*, 53–77.

22. On the history of the National Hotel, see Whittlesey, "'Oh, Mammoth Structure!' 2–20.

23. Sheridan, *Report of an Exploration*, 17–18.

24. *Documents Relating to Yellowstone*, 4.

25. "Game in the National Park," *Forest and Stream* 19, no. 24 (January 11, 1883): 462.

26. *Congressional Record*, 47th Congress, 2nd session, Senate, 3270, 3488.

27. Grinnell, "Their Last Refuge."

28. Rufus Hatch, "Letters to the Editor: Mr. Hatch and the Yellowstone Park," *New York Times*, January 4, 1883, 2.

29. "The Yellowstone Park," *Harper's Weekly* 27, no. 1361 (January 20, 1883): 46.

30. Haines, *Yellowstone Story*, vol. 2, 480.

31. *Documents Relating to Yellowstone*, 4.

32. Grinnell, "Mr. Vest's Victory."

33. Philip H. Sheridan to George G. Vest, January 31, 1883, letter, Sheridan Papers.

34. Philip H. Sheridan to George G. Vest, April 9, 1883, letter, Sheridan Papers.

35. Philip H. Sheridan to Frederick J. Phillips, June 14, 1883, letter, Sheridan Papers.

36. [Untitled], *Livingston Enterprise*, September 8, 1883, 2. See also, Magoc, *Yellowstone*, 120–33; and Glidden, *Exploring the Yellowstone*, 91.

37. Chester A. Arthur to Henry Villard, July 28, 1883, letter, Arthur Papers.

38. Taylor, "Marketing the Northwest."

39. Rufus Hatch to Carroll T. Hobart, May 29, 1883, letter, Hobart Papers.

40. Carroll T. Hobart to Alice Hobart, August 15, 1883, letter, Hobart Papers.

41. Rufus Hatch to Carroll T. Hobart, July 3, 1883, letter, Hobart Papers.

42. "Arrival of the Hatch Party," *Livingston Enterprise*, August 23, 1883, 3.

43. Grinnell, "Seeing the Yellowstone Park."

44. "Is It an Arthur Boom?" *Washington Post*, July 28, 1883, 2.

45. "The Passing of Arthur," *Washington Post*, August 3, 1883, 1.

46. "Is It an Arthur Boom?" *Washington Post*, July 28, 1883, 2.

47. Frank Jay Haynes to Lily Snyder Haynes, August 8, 1883, letter, Jack Ellis Haynes Papers, collection 1504.

48. On Native Americans in Yellowstone, see Loendorf and Stone, *Mountain Spirit*; Nabokov and Loendorf, *Restoring a Presence*; and Spence, *Dispossessing the Wilderness,* 41–70.

49. "A Three Pound Trout," *Livingston Enterprise*, July 3, 1886, 4.

50. Frank Jay Haynes to Lily Snyder Haynes, August 10, 1883, letter, Jack Ellis Haynes Papers, collection 1504. "The President," *Chicago Tribune*, August 10, 1883, 1; "Going to Kidnap the President," *Livingston Enterprise*, August 27, 1883, 2.

52. "Local Layout," *Livingston Enterprise*, August 27, 1883, 3. See also Field, *Sharps and Flats*, 68–70.

53. Hardman, *Trip to America*, 175.

54. "By Telegraph: The Movements of President Arthur and Party," *Livingston Enterprise*, August 30, 1883, 1.

55. Cruikshank and Whittlesey, "A Lady's Trip to Yellowstone, 1883," 11.

56. "From Yellowstone Park," *The Evening Journal* (Jersey City, N.J.), September 8, 1883, 3.

57. Thomas, "My Recollections of Yellowstone."

58. Howe, *Chester A. Arthur,* 254.

59. Hardman, *Trip to America,* 174–75; and "The Presidential Party," *Livingston Enterprise*, September 3, 1883, 1.

60. Robert T. Lincoln to Henry Villard, August 20, 1883, telegram, Arthur Papers.

61. Commemorative Program for the Northern Pacific Railroad Dedication Ceremony in St. Paul, Minnesota, September 3, 1883, document, Arthur Papers.

62. "The Northern Pacific Railroad," *Harper's Weekly* 27 (September 15, 1883): 590.

63. Chester A. Arthur to Michael V. Sheridan, September 14, 1883, document, Arthur Papers.

64. [Untitled], *Livingston Enterprise*, September 8, 1883, 2.

65. Taylor, "Marketing in the Northwest," 34–35.

66. "By Telegraph: The Presidential Party Will Remain in the Park a Day or Two Longer for Gen. Sheridan's Benefit," *Livingston Enterprise*, August 31, 1883, 1.

67. Carroll T. Hobart to Charles F. Hobart, December 19, 1883, letter, Hobart Papers.

68. Carroll T. Hobart to Charles F. Hobart, February 29, 1884, letter, Hobart Papers.

69. Grinnell, "Future of the Park."

70. [Untitled], *Livingston Enterprise*, September 5, 1885, 2.

71. *Documents Relating to Yellowstone*. Quoted in Grinnell, "Yellowstone Park Matters," *Forest and Stream* 22, no. 7 (March 13, 1884): 121.

73. Grinnell, "Yellowstone Park Matters," *Forest and Stream* 21, no. 25 (January 17, 1884): 489.

74. [Untitled], *Weekly Inter Mountain*, October 25, 1883, 2.

75. Vest, "Notes on the Yellowstone Trip."

76. "Mr. Arthur's Own Rooms," *Rocky Mountain News*, September 23, 1883, 16.

77. Philip H. Sheridan to Robert T. Lincoln, October 20, 1883, letter, Sheridan Papers.

78. Unidentified newspaper clipping, n.d., scrapbook, Frank Jay Haynes Papers, collection 1500.

79. Haynes, *Northern Pacific,* 16.

80. Frederick J. Phillips to Frank Jay Haynes, February 1, 1884, letter, Frank Jay Haynes Papers, collection 1500.

81. Robert T. Lincoln to Frank Jay Haynes, January 28, 1884, letter, Frank Jay Haynes Papers, collection 1500.

82. Frank Jay Haynes to Lily Snyder Haynes, n.d., letter, Jack Ellis Haynes Papers, collection 1504.

83. Ibid.

84. [Untitled], *Livingston Enterprise*, January 8, 1884, 2.

85. Grinnell, "President Arthur's Record."

86. [Untitled], *St. Louis Globe Democrat*, August 23, 1884, 4.

87. McClure, *Colonel Alexander K. McClure,* 115.

88. ["Occident"], "A Trip to the Park."

THE PHOTOGRAPHIC ALBUM

1. Edward Dickinson (1850–1917) worked as the general superintendent of the Wyoming division of the Union Pacific Railroad. A native of Cumberland, Maryland, Dickinson began employment as a train dispatcher with the Union Pacific in 1871 and in 1883 was made a division superintendent.

2. In 1882, a monument to Oakes Ames (1804–1873) and his younger brother Oliver (1807–1877) was dedicated at a site near Sherman in Wyoming Territory—the highest point of the recently completed Union Pacific Railroad. The Ames brothers were leading investors in the transcontinental line and championed its construction before and after its completion in 1869. The monument was designed by architect Henry H. Richardson and featured granite bas relief portrait medallions by Augustus Saint-Gaudens. Former president Rutherford B. Hayes attended the dedication ceremony.

3. James H. Lord (1840–1896) served as the depot quartermaster in Cheyenne, Wyoming Territory, from 1880 to 1885. A graduate of the class of 1862 at the United States Military Academy, he participated in several Civil War battles, including Antietam. After the war he worked at various military posts throughout the country.

4. South Pass City was established in 1867 after the discovery of gold in the southeastern region of the Wind River Mountains. Although 1,000 people settled in the community during its boom years, the town was largely abandoned by 1883 due to the discovery of better mining opportunities elsewhere. In 1869, during Wyoming's First Territorial Legislature, local resident William Bright authored and oversaw the passage of the nation's first bill giving women the vote. A year later South Pass City appointed Esther Hobart Morris as the town's justice of the peace, the first woman in America to serve in this capacity. Morris later became the vice president of the National American Woman Suffrage Association.

5. Like South Pass City, Atlantic City was founded during the 1867 gold rush. Its population was also largely gone by 1883.

6. Miner's Delight was the third town in the so-called Sweetwater Mining District that was established in the wake of gold's discovery. To protect miners from the increasingly hostile Native American population, a fort was built in the area in June 1870 and named Camp Stambaugh in honor of First Lieutenant Charles B. Stambaugh, who had recently been killed in an attack by Native Americans. In 1878 the fort was closed after many of the local residents had left the region.

7. Argillaceous sandstone is a sedimentary rock composed primarily of quartz sand, together with a significant amount of clay or silt. Hematite is a type of iron ore. Such rock formations are relatively common in western Wyoming.

8. Situated on the banks of the Popo-Agie River, the town of Lander in Wyoming Territory was named for Frederick West Lander (1821–1862), an engineer for the U.S. Department of the Interior who introduced a new route through the region in 1859 that shortened travel west to Fort Hall in Oregon Territory. Lander died of pneumonia while serving as a Union general during the Civil War. In 1869 Camp Auger was established there, and in 1875 the settlement was renamed Lander.

9. In 1868, the Second Fort Bridger Treaty established the Shoshone Reservation as the home for the Eastern Shoshones and a group of Bannock from Idaho. Although an earlier treaty had designated lands in this region for the Crow tribe, roughly three million acres in the Wind River Valley were set aside for the Shoshones under the leadership of Chief Washakie. In 1878, the military post at the center of the agency was renamed "Fort Washakie." Also, in that same year, roughly a thousand members of the Northern Arapahoes—traditional enemies of the Shoshones—were resettled on the eastern portion of the Shoshone Reservation.

10. Washakie (c. 1798–1900) and Black Coal (1840–1893) were the principal chiefs of the Eastern Shoshone and Northern Arapaho tribes, respectively. Both were renowned warriors who later allied themselves with American authorities. Washakie was especially well known at this time, because he had granted the Union Pacific Railroad permission to lay tracks through Shoshone lands in 1868 and had assisted the U.S. Army during the Great Sioux War of 1876–77.

11. Norcutt (also spelled Norkuk) was a subchief and close ally of Washakie. During Shoshone deliberations with U.S. officials, he often served as an interpreter. The Carlisle Indian Industrial School was an off-reservation boarding school for Native American children. Located in Carlisle, Pennsylvania, the school was founded in 1879 by Captain Richard Henry Pratt, a military officer who believed that the future welfare of Native Americans depended upon cultural assimilation.

12. William P. Clark (1845–1884) joined General Sheridan's staff in 1881. A graduate of the Class of 1868 at the United States Military Academy, Clark served with distinction as the commander of a detachment of Native American scouts during the Great Sioux War. Observing these scouts communicating in sign language, Clark learned this mode of communication and later developed a manual for use by the military, *The Indian Sign Language*, published posthumously in 1885.

13. Sharp Nose was a leading Arapaho chief who had distinguished himself previously as a scout for the U.S. Army. During an exchange of gifts on this occasion, Sharp Nose presented a pony as a present meant for the president's eleven-year-old daughter, Ellen Herndon Arthur (1871–1915). Later that fall, the horse was transported to Washington, where it became a favorite

companion of "Nell." It is of note that earlier in the year Arthur had been offered a young eagle as a gift during his travels in Florida, but he had turned it down.

14. Captain Edward Mortimer Hayes (1842–1912) led the seventy-five-man military escort that accompanied the presidential party during its journey. A Civil War veteran from New York who served under General Sherman during his famous "March to the Sea," Hayes was a career military officer who was later promoted to Brigadier General.

15. One of the important elements in the non-Native campaign to acculturate Native Americans during this period was centered on changing Native attitudes towards land ownership. Rather than tribes holding land "in common," many government authorities and non-Native reformers advocated that property should be owned privately, or "in severalty." The great majority of Native Americans, including the Shoshones and Arapahoes, opposed the idea of individual land ownership.

16. As mentioned in a subsequent dispatch, Crow Heart Butte was named for a battle in 1866 between Shoshone and Bannock warriors and the Crow, who lived to the north. Prompted by a dispute over hunting grounds, the tribes fought nearby for five days. It is believed that the battle culminated with a duel between Washakie and a rival warrior. Washakie was victorious and subsequently cut out the heart of his enemy and placed it triumphantly at the end of his lance during a war dance after the battle.

17. On August 10, the *Chicago Tribune* published an article by an anonymous reporter suggesting that one of its correspondents had surreptitiously joined the president's caravan with the intention of sending back eyewitness reports about the trip. Further, the correspondent wrote, "there are those who predict that an effort will be made by Indians or bands of robbers which are thick around here now to seize Mr. Arthur, carry him into the mountain fastnesses and hold him for ransom." As Arthur was receiving news in the field from military couriers, he learned of this report and ordered that the camp be searched. Although no correspondent was discovered, the *Tribune* continued to write articles—much to the president's consternation—that suggested a reporter was with the party.

18. Captain Robert Torrey (1839–1916), a Civil War veteran, was the commander of Camp Brown in 1871. In June of that year he was ordered to identify a new site for the post. Camp Brown was relocated two years later and, in December 1878, was renamed Fort Washakie. Torrey left the military and in 1878 joined James K. Moore in establishing a ranching partnership.

19. "Shoshone Dick" (life dates unknown) served as a hunter and guide during the trip. It was believed at the time, though it cannot be confirmed at present, that he was born to parents from Arkansas who headed west to California in 1857. While traveling through southern Utah, he was taken captive during the so-called Mountain Meadows Massacre and subsequently raised by a Shoshone family. He had also served as a hunter and guide during General Sheridan's Yellowstone expedition in 1882.

20. Heber Reginald Bishop (1840–1902) was a wealthy merchant and banker who helped to organize the company that built the street railroad system in New York City. Bishop was also a director of several western railroads, and in 1882 he joined General Sheridan during his expedition to Yellowstone.

21. William Henry Forwood (1838–1915) was a surgeon and a naturalist in the U.S. Army. Having traveled on several western expeditions with General Sheridan in the past, including his 1882 Yellowstone trip, Forwood was recruited to serve as the primary medical officer of the 1883 expedition. A graduate of the University of Pennsylvania Medical School, he served with distinction during the Civil War. After the war he held positions at military posts in several southern and western states, ultimately earning the rank of brigadier general.

22. Edward Swift Isham (1836–1902) was a prominent Chicago lawyer who in 1872 partnered with his friend Robert Todd Lincoln to establish the law firm of Isham & Lincoln. Although Lincoln served as U.S. Secretary of War from 1881 to 1885, the two men continued to lead the firm until Isham's death in 1902.

23. The Sheep Eaters had traditionally lived in the mountainous region of present-day northwest Wyoming. A Shoshone band, they had been largely displaced from Yellowstone National Park in accordance with the Indian removal policies of park superintendent Philetus W. Norris. Some moved west to live on the Lemhi Reservation in Idaho, and others joined the Shoshones in the Wind River Valley. General Sheridan employed five Sheep Eater guides during his 1882 Yellowstone expedition.

24. Wade Hampton (1818–1902) was a U.S. senator from South Carolina. Born into a wealthy, slave-owning family, he rose to the rank of lieutenant general in the Confederate Army during the Civil War. After the war, he opposed Reconstruction and became one of the original proponents of the "Lost Cause" movement in the South. During early July 1883, newspaper accounts suggested that Hampton would join the president's trip to Yellowstone, despite the fact that he had lost a leg in a hunting accident in 1878. Like Senator Vest, Hampton was a southern Democrat. General Sheridan had given Vest the opportunity to invite one guest, and it seems likely that he was the person who had approached Hampton. Because Hampton appears to have declined the invitation only weeks before the journey's start—for reasons that are not known—Vest decided to invite his son George G. Vest, Jr.

25. On August 21, the *Chicago Tribune* published an article that reported that the president's party had reached the Upper Geyser Basin, where they were "confronted by a solid wall of forest fire" that forced them to stop for the day.

Not only was no such fire encountered, but the party did not reach this point until August 24. Earlier the newspaper's special correspondent had suggested that Lincoln had remained behind at Fort Washakie, ostensibly to negotiate a new treaty with the tribes there. That report was also a hoax.

26. William Emerson Strong (1840–1891) was a close friend to General Sheridan and accompanied him during the 1882 Yellowstone expedition. A Civil War veteran who was brevetted brigadier general in 1865, he moved to Chicago after the war and became a leading figure in the lumber industry.

27. John Alexander Logan (1826–1886) was a former Union general and a U.S. senator from Illinois. When General Sheridan and Senator Vest first began to organize the presidential expedition, Logan was identified as a potential guest, in part because of his friendship with Sheridan, but also because he served on several Senate committees, including two of special importance in the West: Military Affairs and Indian Affairs. While Logan's participation seemed assured during the late spring, he ultimately declined in early July because of an illness and was replaced by General Anson Stager. Yet, Logan did visit Yellowstone later that summer, in the company of Senator Henry L. Dawes, also a member of the Indian Affairs committee.

28. One of Yellowstone's most-discussed issues at the time was the problem of illegal hunting in the park. In General Sheridan's report following his 1882 expedition, he decried the poaching that was then occurring, especially during the winter months. Yellowstone's superintendent Patrick H. Conger was regularly under fire for his ineffectiveness in upholding the Department of the Interior's regulation that prohibited hunting in the park. Without a suitable police force to enforce the rule, however, he faced a near-impossible challenge in trying to stop it.

29. John Whitney Barlow (1838–1914) and Gustavus Cheyney Doane (1840–1892) were U.S. Army officers who participated in some of the earliest explorations in Yellowstone. Both were Civil War veterans who were stationed in the West after the war. Doane led the military escort that accompanied an expedition in the summer of 1870 headed by Henry D. Washburn and Nathaniel P. Langford. Doane's account of the trip—the first military report to describe Yellowstone's geysers—prompted General Sheridan to direct Barlow and David P. Heap to conduct a military reconnaissance the following summer. Barlow and Heap's report confirmed Doane's and became an important source in the creation of the first Yellowstone map.

30. Although many have doubted it, the story of being able to cook a fish while it was still on the line in a nearby hot pot now called Fishing Cone is, in fact, true. In 1870, members of the Washburn-Langford-Doane expedition first performed this act at Yellowstone Lake. One of the party's members, Walter Trumbull, recalled this episode in the *Overland Monthly* the following spring, and since then it has been frequently repeated in Yellowstone guidebooks and traveler accounts.

31. Edward Drinker Cope (1840–1897) was one of the era's most distinguished scientists in the field of vertebrate paleontology. While he lived in Philadelphia, much of his fieldwork was conducted in the American West. His discovery of rare fossilized remains and his research on extinct species—together with his heated rivalry with fellow paleontologist Othniel C. Marsh—made him well known beyond the scientific community.

32. The earliest non-Native travelers to Yellowstone began assigning names to its different geological elements. New names have frequently been added over time. While "Devil's Caldron" had been named by the Hayden Survey in 1871, "Editor's Hole" seems to have been invented by someone in Arthur's party. Yellowstone historian Lee Whittlesey indicates that there have been at least seventeen different names assigned to this particular spring, which is most commonly referred to as the "Dragon's Mouth Spring" today.

33. Arthur planned his return trip to Washington on the Northern Pacific Railroad. A branch from the main line in Livingston, Montana Territory, to the town of Cinnabar, just outside the park's north entrance at Mammoth Hot Springs, was then being finished. On September 1, right on schedule, a party of railroad officials met the president at Cinnabar, and they traveled together to Livingston.

34. Camp Allison was named for William B. Allison (1829–1908), a six-time U.S. senator from Iowa. In 1882, Allison helped to select fellow Iowan Patrick H. Conger as Yellowstone superintendent.

35. For the third time in the official dispatches, Colonel Sheridan expresses his annoyance with false reports by so-called "special correspondents." While the *Chicago Tribune* was especially guilty of publishing fabricated stories, other newspapers also spread far-fetched rumors about the expedition. On August 24, a report in the *Wood River Times* in Hailey, Idaho Territory, suggested that a plot to kidnap the president was in the works. Newspapers across the nation picked up the story and republished it, setting off some concern about the president's safety. Similar rumors about Arthur's health and "secret" negotiations with different tribes also circulated at this time.

36. John C. Baronett (1827–1906)—better known as "Yellowstone Jack"—built the first bridge across the Yellowstone River in 1871. He also worked as a prospector, a military scout, and a hunting guide. Explorer Ferdinand V. Hayden named a mountain in the northeastern section of the park for him in 1878. Baronett served as a guide for General Sheridan's 1882 expedition and joined President Arthur's party during the time when they were in the park. Mount Washburn was named for General Henry D. Washburn (1832–1871), a Civil War veteran who was appointed the surveyor general of Montana Territory in 1869. The following year Washburn led an expedition in Yellowstone with Nathaniel P. Langford and Gustavus C. Doane. Climbing Mount Washburn became a popular activity during this period, and visitors often left notes in a small tin box under a cairn at its summit.

37. Simon Cameron (1799–1889) was elected to the U.S Senate in 1867 and again in 1873. Formerly he served as Abraham Lincoln's first secretary of war, though his time in that position was brief on account of various indiscretions. A friend of Ulysses S. Grant, Cameron convinced Grant to select his son as his secretary of war.

38. The National Hotel at Mammoth Hot Springs was ready for its first guests in early August. Its owners—Rufus Hatch and the Yellowstone National Park Improvement Company—had hoped that President Arthur and his party would stay there, but upon arriving at Mammoth they decided instead to encamp a half-mile from the hotel.

39. While Arthur's party did not spend the night at the National Hotel, they did venture there for a reception following this musical serenade. According to hotel waiter George Thomas, the reception "was held in a private Dining-room of the Hotel in which Colonel Hatch had arranged wines and cigars to be served for the evening entertainment."

40. In November 1882, the lines of the Northern Pacific Railroad arrived at a trading post community on the Yellowstone River known as Clark City. The decision was made shortly thereafter to move the town a short distance and to rename it Livingston. A branch line was built in 1883 to connect Livingston and Cinnabar, a community at the park's northern entrance.

41. Senator Vest left the party at Livingston and departed to meet Senator Henry L. Dawes and Montana congressman Martin Maginnis (1841–1919). As members of the Senate Committee on Indian Affairs, Vest and Dawes then traveled to several reservations in Montana and the Dakota Territory to meet with tribal officials.

42. Arthur arrived in St. Paul, Minnesota, on September 3, where he, General Sheridan, and Lincoln appeared alongside ex-president Ulysses S. Grant and Henry Villard, the president of the Northern Pacific Railroad, at festivities to celebrate the railroad's completion. Arthur arrived in Chicago the next day, where a large crowd had gathered to welcome him.

BIBLIOGRAPHY

Arthur, Chester A. The Chester A. Arthur Papers. Manuscript Division, Library of Congress, Washington, D.C.

Bann, Stephen, ed. *Art and the Early Photographic Album*. New Haven: Yale University Press, 2011.

Barringer, Mark David. *Selling Yellowstone: Capitalism and the Construction of Nature*. Lawrence: University Press of Kansas, 2002.

Bartlett, Richard A. *Yellowstone: A Wilderness Besieged*. Tucson: University of Arizona Press, 1985.

Bederman, Gail. *Manliness & Civilization: A Cultural History of Gender and Race in the United States, 1880–1917*. Chicago: University of Chicago Press, 1995.

Cruikshank, Margaret, and Lee H. Whittlesey. "A Lady's Trip to Yellowstone, 1883." *Montana the Magazine of Western History* 39 (Winter 1989): 2–15.

Documents Relating to Yellowstone National Park, 1882–84. Washington, D.C.: Government Printing Office, 1884.

Field, Eugene. *Sharps and Flats*. New York: Charles Scribner's Sons, 1900.

Glidden, Ralph. *Exploring the Yellowstone High Country*. Cooke City, Mont.: Cooke City Store, 1982.

Grinnell, George Bird. "The Future of the Park," *Forest and Stream* 22, no. 11 (April 10, 1884): 201.

———. "Mr. Vest's Victory," *Forest and Stream* 20, no. 6 (March 8, 1883): 101.

———. "Our Angling President," *Forest and Stream* 20, no. 11 (April 12, 1883): 210.

———. "President Arthur's Record," *Forest and Stream* 22, no. 21 (June 19, 1884): 401.

———. "Seeing the Yellowstone Park," *Forest and Stream* 20, no. 26 (July 26, 1883): 501–502.

———. "Their Last Refuge," *Forest and Stream* 19, no. 20 (December 14, 1882): 382–83.

———. "Yellowstone Park Matters," *Forest and Stream* 21, no. 25 (January 17, 1884): 489.

———. "Yellowstone Park Matters," *Forest and Stream* 22, no. 7 (March 13, 1884): 121.

Gunnison, Almon. *Rambles Overland: A Trip Across the Continent*. Boston: Universalist Publishing House, 1884.

Haines, Aubrey L. *The Yellowstone Story*. Boulder: Colorado Associated University Press, 1977.

Hardman, William. *A Trip to America*. London: T. Vickers Wood, 1884.

Hartley, Robert E. *Saving Yellowstone: The President Arthur Expedition of 1883*. Westminster, Colo.: Sniktau Publications, 2007.

Haupt, Herman. *The Yellowstone National Park*. St. Paul, Minn.: J. M. Stoddart, 1883.

Haynes, Frank Jay. The Frank Jay Haynes Papers. Burlingame Special Collections, Montana State University–Bozeman Libraries.

———. *Northern Pacific and National Park Views*. St. Paul, Minn.: Pioneer Press Company, 1884.

Haynes, Jack Ellis. "The Expedition of President Chester A. Arthur to Yellowstone National Park in 1883." *Annals of Wyoming* 14 (January 1942): 32–38.

———. The Jack Ellis Haynes Papers. Burlingame Special Collections, Montana State University–Bozeman Libraries.

Hebert, Grace Raymond. *Washakie: Chief of the Shoshones*. Lincoln: University of Nebraska Press, 1995.

Hobart, Carroll T. The Carroll T. Hobart Papers. Yale Collection of Western Americana, Beinecke Rare Book and Manuscript Library.

Howe, George Frederick. *Chester A. Arthur: A Quarter-Century of Machine Politics*. New York: Frederick Ungar Publishing Company, 1935.

Hutton, Paul Andrew. *Phil Sheridan and His Army*. Norman: University of Oklahoma Press, 1999.

Lears, T. J. Jackson. *No Place of Grace: Antimodernism and the Transformation of American Culture, 1880–1920*. Chicago: University of Chicago Press, 1981.

LeClercq, Jules. *La Terre des Merveilles*. Paris: Libraire Hachette et Cie, 1886.

Loendorf, Lawrence L., and Nancy M. Stone. *Mountain Spirit: The Sheep Eater Indians of Yellowstone*. Salt Lake City: University of Utah Press, 2006.

Magoc, Chris J. *Yellowstone: The Creation and Selling of an American Landscape, 1870–1903*. Albuquerque: University of New Mexico Press, 1999.

Marcus, W. Andrew, et. al. *Atlas of Yellowstone*. Berkeley: University of California Press, 2012.

McClure, Alexander K. *Colonel Alexander K. McClure's Recollections of Half a Century*. Salem, Mass.: The Salem Press Company, 1902.

Montana Historical Society. *Frank Jay Haynes, Photographer*. Helena: Montana Historical Society Press, 1981.

Nabokov, Peter, and Lawrence L. Loendorf. *Restoring a Presence: American Indians and Yellowstone National Park*. Norman: University of Oklahoma Press, 2004.

Norris, Philetus W. *The Calumet of the Coteau and Other Poetical Legends of the Border*. Philadelphia: J. B. Lippincott & Co., 1883.

["Occident"], "A Trip to the Park," *Forest and Stream* 27, no. 14 (October 28, 1886): 262.

Pierrepont, Edward. *Fifth Avenue to Alaska*. New York: G. P. Putnam's Sons, 1884.

Reeves, Thomas C. *Gentleman Boss: The Life of Chester Alan Arthur*. New York: Knopf, 1975.

———. "President Arthur in Yellowstone National Park." *Montana the Magazine of Western History* 19 (July 1969): 18–29.

Reiger, John F. *The Passing of the Great West: Selected Papers of George Bird Grinnell*. New York: Charles Scribner's Sons, 1972.

Schullery, Paul. *Searching for Yellowstone: Ecology and Wonder in the Last Wilderness.* Boston: Houghton Mifflin Company, 1997.

Sheridan, Philip H. The Philip H. Sheridan Papers. Manuscript Division, Library of Congress, Washington, D.C.

———. *Report of an Exploration of Parts of Wyoming, Idaho, and Montana in August and September, 1882.* Washington, D.C.: Government Printing Office, 1882.

Siegel, Elizabeth. *Galleries of Friendship and Fame: A History of Nineteenth-Century American Photograph Albums.* New Haven: Yale University Press, 2010.

Smith, Duane A. *Henry M. Teller: Colorado's Grand Old Man.* Boulder: University Press of Colorado, 2002.

Spence, Mark D. *Dispossessing the Wilderness: Indian Removal and the Making of the National Parks.* New York: Oxford University Press, 1999.

Taylor, Jan. "Marketing the Northwest: The Northern Pacific Railroad's Last Spike Excursion." *Montana the Magazine of Western History* 60 (Winter 2010): 16–35.

Thomas, George. "My Recollections of Yellowstone Park." 1938. Manuscript in the Yellowstone National Park Heritage and Research Center.

Tilden, Freeman. *Following the Frontier with F. Jay Haynes.* New York: Alfred A. Knopf, 1964.

Vest, George G. "Notes on the Yellowstone Trip." *Forest and Stream* 21, no. 15 (November 8, 1883): 282.

Villard de Borchgrave, Alexandra, and John Cullen. *Villard: The Life and Times of an American Titan.* New York: Doubleday, 2001.

Whittlesey, Lee H. "'Everyone Can Understand a Picture': Photographers and the Promotion of Early Yellowstone." *Montana the Magazine of Western History* 49 (Summer 1999): 2–13.

———. "'Oh, Mammoth Structure!': Rufus Hatch, the National Hotel, and the Grand Opening of Yellowstone in 1883." *Annals of Wyoming* 83 (Spring 2011): 2–20.

———. *Storytelling in Yellowstone: Horse and Buggy Tour Guides.* Albuquerque: University of New Mexico Press, 2007.

———. *Yellowstone Place Names.* Gardiner, Mont.: Wonderland Publishing Company, 2006.

———, and Elizabeth A. Watry, eds. *Ho! For Wonderland: Travelers' Accounts of Yellowstone, 1872–1914.* Albuquerque: University of New Mexico Press, 2009.

Winser, Henry J. *The Yellowstone National Park: A Manuel for Tourists.* New York: G. P. Putnam's Sons, 1883.

INDEX